IMAGE STREAM

Helen Molesworth

Wexner Center for the Arts

The Ohio State University

Columbus, Ohio

2003

Published in association with
Image Stream
September 20, 2003–January 4, 2004
Curator: Helen Molesworth

organized by
Wexner Center for the Arts
The Ohio State University
Columbus, Ohio

on view at
The Belmont Building
330 West Spring Street
Columbus, Ohio

Image Stream is presented with support
from **Nancy and Dave Gill** and the **Corporate
Annual Fund of the Wexner Center Foundation.**

Promotional support is provided by **WBNS 10TV**
and **Time Warner Cable.**

© 2003 Wexner Center for the Arts
The Ohio State University

Graphic Designer: Jeffrey M Packard
Editor: Ann Bremner
Assistant Editor: Ryan Shafer
Curatorial Assistants: Joby Pottmeyer, Steven Hunt

Published by
Wexner Center for the Arts
The Ohio State University
1871 North High Street
Columbus, Ohio 43210-1393
USA
Tel: +614-292-0330
Fax: +614-292-3369
www.wexarts.org

ISBN: 1-881390-34-9

STORYTELLING
DIRECTOR'S FOREWORD

I COULDN'T QUOTE YOU NO DICKENS, SHELLEY OR KEATS
'CAUSE IT'S ALL BEEN SAID BEFORE
MAKE THE BEST OUT OF THE BAD JUST LAUGH IT OFF
YOU DIDN'T HAVE TO COME HERE ANYWAY
SO REMEMBER, EVERY PICTURE TELLS A STORY DON'T IT
—Rod Stewart/Ron Wood, 1971

Artists have been telling stories for millennia. Mythology, religion, ideology, morality, mundanity, phenomenology, sexuality, and all the rest are age-old fodder for the creative imagination. Creativity itself, originality, authenticity, essentiality—and all their discontents—have worked themselves into the narrative, as if things weren't already complicated enough. And once artists ran the gamut of what "art" could be, what constituted its legitimate material and psychic boundaries (if any such exist), it was inevitable that the once degraded, hopelessly bourgeois medium of video would loom large, perhaps larger than anyone might have anticipated.

The first generation was, as they always are, a bit rough around the edges: raw, rambunctious, rebellious. As Greil Marcus said of Rod Stewart's contemporaneous *Every Picture Tells a Story*, it presented a "mature tale of adolescence, full of revelatory detail." This was the 1960s and 1970s, a time of in-your-face audacities, in the galleries as well as on the streets. The second generation, not coincidentally in full force around the time of Stephen Soderbergh's *Sex, Lies, and Videotape* (1989), was bound to be more permissive in its pleasures. In creep narrative, humor, beauty, even the sublime, as storytelling and spectacle reassert their once proud claim on the art-making impulse.

By the time a third generation had emerged, the thrall of adolescent angst had subsided into the calm self-confidence of a medium that had at last found its stride. Forays through formalism, materialism, conceptualism, identity politics, and all the other signposts of modern and contemporary art now proudly wear a coat of many colors: classic modernism, New Wave, Hollywood, video journalism, and MTV, all woven together in a pixilated pantheon of streaming images.

In her first exhibition for the Wexner Center, Helen Molesworth seeks to explore this phenomenon and its concomitant effect on the culture of art consumption. She reveals a medium that has come to know itself technically and conceptually, detecting that which it does better than any other: Today's video artist watches with uncanny perspicacity, commenting with poetry, humor, and poignance on the full spectrum of our everyday lives—from minutiae to grand designs, from burlesques to tragedies. Molesworth has chosen a veritable rogues' gallery of film and video talents. Kutlug Ataman, Matthew Barney, Tacita Dean, Andrea Fraser, Pierre Huyghe, Neil Jordan, Donald Moffett, and Lorna Simpson cast an acutely vivid—and multifaceted—lens onto the cinematic landscape as it merges with the museological.

STORYTELLING

In her inspired selection of both specific artists and particular works, Molesworth has artfully illuminated the plethora of influences, inspirations, and shameless pilferings drawn from mass media, all while making a compelling case for a genre *sui generis*. She is expertly assisted in her exposition by an erudite team of curators, critics, and writers who contribute their own distinctive voices to the publication that accompanies the exhibition, and we are grateful to George Baker, Gregg Bordowitz, Aruna D'Souza, Bill Horrigan, Bruce Jenkins, and Hamza Walker, for joining Molesworth in this lively conversation. In an age of rampant media savvy, this team has distinguished itself with sheer, undisputed expertise.

It is perhaps long overdue that the Wexner Center organize an exhibition exclusively composed of film and video works. Not that we haven't frequently presented such work in the context of thematic shows or single artist projects. In fact, thanks in large measure to our unique Art & Technology facility, the center has become something of a beacon for independent film and video artists who come from throughout the world to do post-production work under the tutelage of our exceptional media staff. Three such former artists in residence—Tacita Dean, Lorna Simpson, and Andrea Fraser—return to grace the *Image Stream* galleries, and we are delighted to welcome them back.

I would like to express my utmost gratitude to the staff of the Wexner Center for their talents and tenacity in mounting a dynamic program of exhibitions outside our traditional habitat. Their energy and enthusiasm for pursuing off-site activities during our gallery renovations is to be commended. For the realization of *Image Stream* in particular, I am proud to acknowledge the special contributions of Benjamin Knepper and Joan Hendricks, who led the

registration and installation team, and Stephen Jones, who brought his techno-wizardry to the task with usual aplomb. Curatorial Assistants Joby Pottmeyer and Steven Hunt provided their always formidable research and sleuthing talents under the vigilant gaze of Exhibitions Manager Jill Davis. The catalogue was overseen by our master of editorial etiquette, Ann Bremner, and designed by the ever enterprising Jeffrey Packard. I am also grateful to a host of staff members and volunteers throughout the center, from administration to development to communications to education, for the dedication with which they helped to bring this project to fruition. Special mention is reserved here for Bill Horrigan, our curator of media arts, for the keen insights and sugges-tions he shared with Helen from the project's very conception.

It is always a pleasure to recognize our lenders and colleagues in the field for their gracious cooperation in assembling the exhibition. We appreciate the assistance of the Irish Museum of Modern Art, the Museum of Contemporary Art, Chicago, the San Francisco Museum of Modern Art, the Whitney Museum of American Art, Marianne Boesky Gallery, Barbara Gladstone Gallery, Marian Goodman Gallery, Sean Kelly Gallery, Lehmann Maupin Gallery, and Friedrich Petzel Gallery. All have been most generous.

I wish to express my heartfelt thanks to Dave and Nancy Gill for their personal contribution toward funding the *Image Stream* exhibition, in addition to the support they offer the center in so many ways throughout the year. We are also grateful to the many generous patrons from near and far that make such programmatic ambitions a reality at the Wexner Center. Above all, I extend my abiding appreciation to the trustees of the Wexner Center Foundation, whose unfaltering support remains an extraordinary gift to me and to the center.

Finally, it is my foremost pleasure to thank Helen Molesworth, for producing, directing, and editing her first "moving picture" for the Wexner Center, and to applaud each of the artists she so masterfully cast in her exhibition debut here.

Sherri Geldin

IMAGE STREAM

Helen Molesworth

THE HYGIENIC ISOLATION OF THE WHITE CUBE
HAS SLOWLY, BUT STEADILY, BEEN OVERTAKEN
BY AN INCREASINGLY PROMISCUOUS BLACK BOX.
AS ANY TURN-OF-THE-CENTURY MEMBER OF THE
ART PUBLIC KNOWS, DARKENED ROOMS AND HEAVY
BLACK CURTAINS SIGNAL THE OMNIPRESENT FILM
AND/OR VIDEO INSTALLATION. FROM INTERNA-
TIONAL BIENNIALS, TO CHELSEA GALLERIES,
TO MUSEUMS OF CONTEMPORARY ART, THE
PROJECTED IMAGE HAS THOROUGHLY TAKEN HOLD
OF CONTEMPORARY ARTISTS' IMAGINATIONS.

One effect of this development is that the stream of moving images that defines contemporary visual culture has seeped into the water table of contemporary art as well. Like prints and photographs, the moving image now slides effortlessly along what once would have been described as a high/low axis. Yet from television to the Tate, and back again, it's hard to impose an easy hierarchy along this spectrum. Rather "high" and "low" seem to interpenetrate one another to an astounding degree, as all spheres of the moving image beg, borrow, and steal from one another as equal opportunity opportunists. Despite the seduction of finding this stream of moving images in the art world, the current predominance of film and video installations begs a dual set of questions. One is informed by zeitgeist: Why now? Why this? The other is historical in nature: Where did this come from? And is the present moment defined by rupture or continuity with the past?[1]

The history of video's emergence into the sphere of art has its conventional narrative beginnings with the invention of the Sony Portapak. This video camera was distinguished by its relative light weight, portability, and ease of use. These attributes, combined with its general affordability, made video available to a variety of artists, from Vito Acconci, who used the new medium to document his studio-based performances, to Nam June Paik and Gary Hill,

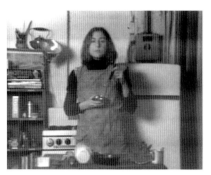

IMAGE
STREAM

who explored the formal and phenomenological possibilities of video projection, to Martha Rosler, who advocated that the easy dissemination of video made it available for a kind of anti-television guerilla TV. Hence, from its inception, the uses to which the medium was put were deeply heterogeneous. Yet one unifying principle was the way in which video, in the context of the art world, registered the gallery/museum system, either through negating its demand for a commodifiable object, or by establishing a relay between the space of commerce and the more hermetic space of the artist's studio. This meant that gallery-based video took part in the larger challenges being leveled at the commercial institutions of art by movements such as conceptual art, earth art, and feminist art. Not properly an object, video lent itself to an art whose intellectual and philosophical trajectory would emanate from experience rather than possession. Thus projected works were, to use the privileged terms of the period, more about process than product.

In addition to single-channel video, the 1960s and 1970s also witnessed a plethora of experiments with projected imagery; artists worked with video installations (e.g., Dennis Oppenheim), double-screen film projections (e.g., Paul Sharits), and slide shows (e.g., Dan Graham), as well as 8mm film (e.g., Richard Serra). Many of these projected pieces rode slipstream on the phenomenological concerns set forth by artists involved with minimalist sculpture. And, like their video counterparts, artists working with projection were interested in challenging the increasing commodification of the gallery system. Borrowing ideas from traditionally defined cinematic space, these artists insisted on an art meant to be viewed in a social setting. In other words,

Vito Acconci
Theme Song, 1973

Martha Rosler
Semiotics of the Kitchen,
1975

artists who operated with projected images desired an art practice that did not imagine the traditional solitary museum/gallery viewer but rather convened some kind of public. In addition to the evocation of an idealized audience, projection works shared the dimension of being time-based, meaning that the experience of these works was rooted in duration, with the viewer asked to participate in a sensory experience of a length determined by the artist.

The emphasis on duration, process, and experience often meant that video and projected works of the 1960s and 1970s were deeply non-narrative. Concurrent with the rejection of the gallery system, there was an equally strong refusal of the dominant forms of the mass media in general, and television and Hollywood film in particular. The rejection of narrative was also enabled by decades of twentieth-century avant-garde artistic practice for which the figure was an anathema. Modernism's pursuit of abstraction often took the form of a rigorous working through of the formal problems of a given medium. So too early projected and video works eschewed narrative and focused instead on explorations of perception, temporality, and the relationship and disjuncture between sound and image, all aspects specific to the media of film and video. The rejection of narrative was also bound up with a stance against spectacle culture. Television was seen as offering an administered form of leisure complete with a demand to shop. Hollywood cinema was seen as either "low brow" or inextricably bound to the ideological agendas of bourgeois culture. Hence, when artists looked to film, they often turned to the traditions of auteur and structuralist cinema. They valued auteur cinema in large measure due to a sense of affinity or shared desire to conceive of individual films and/or videos as discrete works of art, which articulated the problem and/or vision of a particular director/artist. This form of cinema (typified first by Alfred Hitchcock and then by Jean-Luc Godard) was privileged over those generic films made by the Hollywood machine, in part because it promoted the vision of a single author. Auteur cinema remained committed to narrative while structuralist film championed an anti-illusionist mode of working, one often deploying real-time aesthetics "as a means of subverting illusionist codes of montage," where "duration, and the reflexive attention to the materiality of the medium, was understood as anti-idealist technique, and outside the meaning-production mechanisms of dominant ideology."[2]

Now, however, the dominance of moving images is hardly shaped by a purely oppositional paradigm to either the commercial gallery system or Hollywood cinema. The scale of the new projected images (on par with or

larger than many multiplex cinema screens), combined with the use of surround sound (so the viewer is immersed in an auditory field as opposed to focusing solely on the visual), means that many pieces appear to have absorbed the language, and the technological bells and whistles, of traditionally defined spectacle culture. Unlike their 1960s' predecessors, who were often concerned with the formal properties of film, contemporary artists willingly explore visual forms borrowed from both Hollywood and auteur film, as well as television, MTV, CNN, and the theater. This profligate borrowing of mass-media forms has been accompanied by a strong impulse towards narrative. Given the medium's decidedly oppositional and non-narrative beginnings, this seeming embrace of mass culture and its storytelling devices signals a significant shift in the trajectory of the medium.

During the late 1980s and early 1990s much of the art world was concerned with the problem of identity. The artist was no longer considered an abstract entity; rather, ethnicity, gender, and sexuality were all seen to be increasingly important aspects of how art was made, what its concerns were, and how it was perceived. Furthermore, identity was no longer seen as a given but rather as a highly constructed, learned, and fabricated set of coordinates. During this period, representations of the figure, long excluded from minimalism and process art, returned, as did a growing concern with the power of art to convey both critical and emotional material. Sometimes grouped under such terms as "identity politics" or "multiculturalism," much of this work was rooted in photography (e.g., Lorna Simpson), and, further, its exploration of photography often began as a critique or unpacking of mass-produced images found in the realms of advertising, television, and mainstream film (e.g., Barbara Kruger). Concurrent with this exploration of identity in art, equal attention was paid to a critique of representation as such. Works in this vein often focused on how the mass media operates, through a critical staging, or dismantling, of representational codes, such as presentations of masculinity and femininity (e.g., Richard Prince) and the structure of the gaze (e.g., Cindy Sherman). Wittingly or not, both practices quietly smuggled the figure back into contemporary art, and, with the figure, the potential for narrative. Matthew Barney's *Drawing Restraint 7*, which appeared in the 1993 Whitney Biennial (accused and lauded for its exploration of identity politics in art), was an early instance of this development. The work cannily combined sculptural concerns (three monitors hang suspended from the ceiling) with the emerging language

Barbara Kruger
Untitled (Why Are You Here?), 1990

Cindy Sherman
Untitled, Film Still, 1978

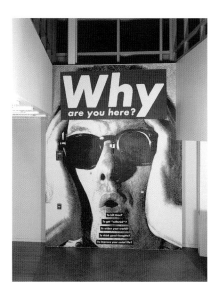

of installation (the work appears in a pristine white room lit with florescent lights). On the monitors viewers watched the return of the body and narrative as satyrs danced and frolicked in a frenzy of polymorphous perversion.

Another structuring condition for the return of narrative into the space of art came from the changing parameters of the movie industry. Blockbuster opened in 1985 as a single video store; less than twenty years later 8,500 stores dot the American landscape, attracting more than three million customers each day. The ability to watch films at home, to customize the viewing environment, and to stop, start, and rewind the tape gave viewers unprecedented control over the previously rigid structures of a time-based medium. In concert with the rise of home movie viewing, independent film distribution was sharply curtailed as repertory movie theaters around the country went out of business and Hollywood incorporated independent production into the studio system. It is against the backdrop of these historical coincidences that gallery-based film and video installations have become so predominant.

• • •

Now when one encounters projected works in galleries and museums one experiences a plethora of formal presentations. In *Image Stream* this hetero-

geneity runs the gamut: large-scale split screen projections, such as Pierre Huyghe's *The Third Memory*; multiple monitors arranged in a grid formation in Lorna Simpson's *31*; screens suspended from the ceiling to create a mini-malist sculptural form, as in Kutlug Ataman's *The 4 Seasons of Veronica Read*; the hospitalesque monitors of Matthew Barney's *Drawing Restraint 7*. In *What Barbara Jordan Wore* Donald Moffett projects video onto monochrome gold canvases, whereas Tacita Dean mimes traditional cinematic space by project-ing *Fernsehturm* with a 16mm film projector. Andrea Fraser's monitor-based *Little Frank and His Carp* harkens back to a kind of guerilla filmmaking, and Neil Jordan's version of Samuel Beckett's *Not I* exploits the multiple view-points afforded by both the camera and a proliferation of monitors. If formal experimentation in the 1960s and 1970s tended to focus on either the phenom-enological problems of the viewing body or the medium-specific attributes of film and video then contemporary artists tend to borrow these strategies as a way to put pressure on the moving image as it is encountered in media culture. Yet far from using specifically art world developments to challenge the mass media as such, contemporary artists also poach freely from the entertainment industry both in terms of content (consider Huyghe's use of the Hollywood film *Dog Day Afternoon*) and in terms of form (the wall of monitors in Simpson's *31*). This reciprocity between what might be described as exclusively art world concerns and spectacle culture is a defining characteristic of contemporary projected images. Thomas Zummer has gone so far as to argue that projected-image installations perform "an important series of translations between the somewhat circumscribed and insular context of the art world and a global field of increasing mediation," making it all the more crucial to our assessments of contemporary visual culture to narrate the two worlds simultaneously, with all of their points of contention, divergence, and reciprocity.[3]

During the 1980s and 1990s artists engaged in a "critique of representa-tion" or, alternately, attempted to produce images that would act as a correc-tive to negative or stereotypical representations; currently many artists operate instead within the cracks or fissures of the mass media, often through a strategy of recoding, by which a traditional narrative form is borrowed only to be occupied and/or written over in such a way that subverts it.[4] Andrea Fraser's *Little Frank and His Carp* does this quite explicitly. We watch the artist rent the introductory Acoustiguide for the Guggenheim Bilbao. Subsequently, we listen to a British male voice, not edited or altered in any way, intone the sensuous

glories of the Frank Gehry building. As the artist obeys the instructions to succumb, in wonder, to the genius of the architect and the power of the museum, she begins to stroke the building's walls. Yet far from submitting docilely, she soon begins to make love to the building in a way that simultaneously literalizes the language of the Acoustiguide and participates in the gag quality of *America's Funniest Home Videos*, all the while sabotaging the self-narration of the museum. Fraser allows institutional narrative to undo itself, whereas Pierre Huyghe often finds a fissure within a conventional Hollywood narrative, and like water freezing and expanding within a rock, tries to cleave open a space for individual recognition within it. In *The Third Memory* he permits the real-life "hero" of Sydney Lumet's *Dog Day Afternoon* (1975), John Wojtowicz, to reenact his version of the bank robbery made so famous by the mass media's real-time capturing of it on live TV news and its subsequent mythologization by Hollywood. While Wojtowicz's performance in *The Third Memory* is shot through with massive moments of self-grandeur and mis-recognitions, he nonetheless articulates a self-representation in the face of spectacle culture. In this regard Huyghe "has developed a reappropriation strategy that employs and yet undermines Hollywood's techniques and principles of exploitation," by counteracting "the entertainment industry's appropriation of an individual's own image."[5]

Some artists seek to recode the narratives of the culture industry; others have chosen to co-opt and complicate formal devices of works from the 1960s and 70s, cross-pollinating them with formal and narrative strategies borrowed from spectacle culture. One of the hallmarks of structuralist film and early experiments with projected works was the anti-illusionist challenges of real time; however, the emergence of real time in the mass media (in the guise of CNN-style news programming, court TV, and reality television) poses the question of the radicality of any formal device as such. Indeed, Tacita Dean and Lorna Simpson both flirt with the problem of real time and its ultimate impossibility. In Dean's *Fernsehturm* we watch a day unfold, from an emerging dawn to the inevitable nightfall, out of the windows of a revolving rooftop restaurant in an old television tower in the former East Berlin. The camera remains immobile, squarely placed on a moving platform; nonetheless we witness constant, achingly slow movement. Long takes of approaching light are interspersed with cutaway shots of the wait staff in the center of the restaurant walking to and fro as they wait on their customers. The sheer banality and predictability of the

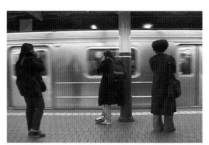

Lorna Simpson
31, 2002

narrative structure—every day the sun rises and sets, every day we must eat and go to work—offsets the incremental beauty of the unfolding light. Although the film is only forty-four minutes long, the effect of time's passage is extraordinary. Here Dean compresses time through editing, not to circumscribe the viewer into a false sense of identification or suspension of disbelief, nor to evoke a purely phenomenological state of visual experience (e.g., Michael Snow), but rather to focus on the mixed-up spaces of work and leisure and the dialectical tension between the revolutions of the earth around the sun and the ever shifting revolution of political power. Lorna Simpson's *31* also borrows freely from a 1970s' feminist film history in which real time and/or duration was of utmost importance since it stood in opposition to a dominant (read patriarchal) narrative logic structured by climax and strove instead for a cinema in which the subject position engendered by the camera was not seen to be exclusively masculine and/or voyeuristic. So while the day-to-night narrative structure of *31*—which follows a woman through a month of repetitive days consisting of waking up, going to work, and returning home—evokes Chantal Akerman's *Jeanne Dielman, 23 Quai du Commerce, 1080 Bruxelles* (1975), the multiple

monitors exploit the logic of relentless real-time imagery on CNN's split-screens, security cameras, and banks of televisions for sale in department stores. *31* provisionally recodes the current condition of the constantly monitored life (from reality TV, to human interest stories, to security checks), imaging instead a profoundly private life. Although shown in exacting detail, *31* offers the viewer relatively little insight, given that at the end we have watched the main character for thirty-one days, and still she remains nameless.

 The mixture of art world concerns and mass-media spectacle in contemporary video and film installations is also born of dramatic changes in the condition of both museums and mainstream movies. Museums have increasingly been co-opted as part of a leisure tourist economy, ever hopeful of growing audiences of non-experts. The movie industry has been changed by the simultaneous proliferation of home viewing and the rise of the multiplex theater. Both occurrences have helped to contribute to the development and marketing of mainstream movies and museum exhibitions to audiences conceived of in terms of highly specific demographics. The difference in the temporality offered by the museum as a leisure destination, in which the audience is imagined to be on a kind of elaborate "stroll" through the galleries, and the creature comforts of the home video center ironically and dialectically structure contemporary projected works. The rise of the VHS tape allowed a new verb to enter the field of movie viewing: rewind. The ability to stop the image stream, to rewind it, to watch the same film or scene over and over again defines the contemporary experience of movies. In some mildly utopian sense the video store offers a protected eddy from mass culture's rushing image stream. Here movies can be sampled like so many songs in a mixed tape. As in the film *High Fidelity* (2000), in which the mixed audio tape is imaged as a moment of fleeting perfection and intense collectivity, so too scenes from films and television have begun to form a lingua franca of contemporary culture.[6] Despite the intensity of control enacted over the moving image at home, within the gallery space the overriding formal presentation is the loop. In the museum and/or gallery the image stream is constantly moving, playing whether the viewer settles in to watch, pauses, or simply walks past without stopping. Distinctly unlike cinema, with its defined start and end time, contemporary art's deployment of the moving image is premised on continual availability. This has caused much consternation, not the least of which is because audiences are unsure of how to behave. Should they stay to the "end"?

What is the end (and when will it come) if the piece is a loop? Is the loop a mere exhibition convenience or is it a structural device inherent to the meaning of contemporary projected works?

Some works have begun to stage the question of the loop spatially. Kutlug Ataman's *The 4 Seasons of Veronica Read* consists of four screens suspended to form an open cube. Onto each screen is projected a different film, of the same woman discussing her obsession with the amaryllis flower. Viewers are aware that wherever they stand they are "missing" something on another screen, which they can see but not hear. The cube functions like a minimalist sculpture, bumping the viewer around from one side to another, not to apprehend sculptural form, but to try and garner the entirety of the woman's narrative. In effect the action of the viewer mimes the problem of the loop, as one literally loops around the work ever trying to catch up with the images that have preceded your arrival.

Neil Jordan's translation of Samuel Beckett's theater piece *Not I* into a gallery-based presentation also spatializes some of the functions of the loop. Six monitors are arranged in a circle on plinths, equally summoning the language of minimalism, theater in the round, and historical structures like Stonehenge. The viewer here is placed in the center, spinning around to take in the six monitors. The monologue itself is a struggle to tell a story without the first person pronoun. On the one hand the work is a stuttering tour-de-force of modernist experimentation with language, yet in its move from theater piece to museum object the role of the viewer undergoes a transformation. Placed in the center, the viewer is now potentially "on stage" and is offered the omnipotent space of a central I, only to find that such a central position disallows any such mastery. In the theater the audience would be released when the monologue was complete; here the loop structure means the viewer, already potentially unable to synthesize the experience of the six monitors, must now also decide if and when to leave, to abandon the promised, yet unfulfilled, position of "I."

The loop is diffident: it doesn't care if or when you're there. The loop fosters a sense that the traditional narrative trajectory of beginning, middle, and end no longer applies. On the other hand, the loop is accommodating, making the work ever available, and if it doesn't permit the verb to rewind, it offers in its place endless repetition. If the VHS tape's proposition is that the temporal dimension of the moving image can be halted, the narrative

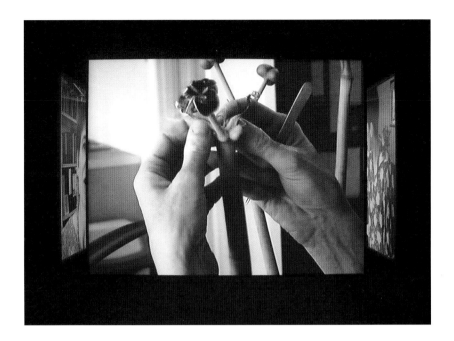

disrupted, the scene fetishized, then the loop seems to be its dialectical other, not rupture but a steady moving stream, preserving and extending the temporal dimension of the projected piece. As much as the loop may be a function of diffident necessity, it may also be an attempt to alter the current model of the museum visitor as one who strolls through space.[7] The temporal dimension of projected works, which is in some ways heightened or amplified by the return of narrative, signals the desire on the part of artists to exact from viewers some of their *time*, to disrupt or slow down the seamless promenade from the ticket counter to the gift shop. So too, the public address of projected works, their creation of a social space, and hence the possibility for an audience (as opposed to a single viewer), is also bound up in the desire not only to slow people down, but to convene them, however provisionally, in a common space, as an audience as opposed to a passerby.

Donald Moffett's *What Barbara Jordan Wore* consists of three monochromatic gold canvases onto which are projected three separate images from the same historical event: Barbara Jordan's twelve-minute speech to the House

IMAGE
STREAM

Judiciary Committee proceedings on the impeachment of Richard Nixon.
On one painting we see Jordan, resplendent in a hot pink suit, reading her
prepared remarks; on the other two panels we see her two distinct audiences,
committee members on the one hand and the spectators on the other. We
understand from the format of the speech that we should listen to it from
beginning to end, yet as the projected images flicker and shimmer on the gold
paintings we realize we are also being asked to look at a painting for a defined
period as well. Here the model of the stroll is altered: neither a painting nor
a video is something to walk by. Rather, through their marriage, viewers are
asked to consider not only their relation as viewer to the work but as audience
to Congresswoman Jordan's speech. Much as Neil Jordan reconfigured the
theater audience in museum space, Moffett asks for a public, indeed *civic*,
audience for art. By interrupting the logic of the leisurely stroll, Moffett, like
many of his contemporaries, seems to suggest that the model of undifferenti-
ated leisure offered by the stream of images in the museum, and the image
stream of the culture industry, can perhaps be productively dammed by

Donald Moffett
What Barbara Jordan
Wore, 2002

mutually subjecting each to the logic of the other. If viewers stop their stroll, and pause for the duration of the work (and perhaps even its repetition), can they find an emotional, critical, and poetic relationship with projected images that is neither manipulative nor numbing? Can they find a shared viewing experience meant to engender a public capable of absorbing narratives of identity that are far from readymade? Can their leisure time find a space that is neither the regimented temporality of Hollywood and television nor the absent-minded promenade though the museum? And could such a version of leisure engender a different subject—one for whom politics and pleasure, fiction and fact, rewind and loop were not diametrically opposed but flowed together to create a new topography for moving images?

Notes

1. The impulse to historicize this material can be seen in curator Chrissie Iles's exhibition *Into the Light: The Projected Image in American Art 1964–1977*, held at the Whitney Museum of American Art, October 18, 2001–January 6, 2002, as well as in the journal *October,* which recently dedicated an issue to "The Projected Image in American Art of the 1960s and 1970s," *October* 103 (Winter 2003), and convened a roundtable discussion on "The Projected Image in Contemporary Art," *October* 104 (Spring 2003).

2. Catherine Russell, *Experimental Ethnography: The Work of Film in the Age of Video* (Durham and London: Duke University Press, 1999), p. 159. My thanks to J. Ronald Green for sharing this book with me.

3. Thomas Zummer, "Projection and Dis/embodiment: Genealogies of the Virtual," in *Into The Light: The Projected Image in American Art 1964–1977*, the catalogue of the Whitney exhibition mentioned above (New York: Whitney Museum of American Art; distributed by H. N. Abrams, 2001), p. 77.

4. In his essay on meaning in film "The Third Meaning," Roland Barthes writes: "The *contemporary* problem is not to destroy narrative but to subvert it; today's task is to dissociate subversion from destruction." *Image Music Text,* trans. Stephen Heath (New York: Hill and Wang, 1977), p. 64.

5. Christian Rattemeyer, "Pierre Huyghe," *Documenta 11 Platform 5: Exhibition Short Guide* (Ostfildern, Germany: Hatje Cantz Verlag, 2002), p. 116.

6. I am indebted to Graham Leggat for this sense of the importance of the scene in contemporary film. No where is this more evident than in *The Sopranos*, in which the characters repeat their favorite scenes from films like *The Godfather* in almost every episode, and the screenwriters self-consciously style scenes to mimic the structure of famous scenes from mob movies.

7. In the *October* roundtable on "The Projected Image in Contemporary Art" Chrissie Iles refers to this model as the " 'going for a walk' of museum and gallery viewing," p. 80.

KUTLUG ATAMAN

THE 4 SEASONS OF VERONICA READ

2002

ALL TALK
Bill Horrigan

THE 4 SEASONS OF VERONICA READ COULD
HAVE BEEN—MIGHT HAVE BEEN, POSSIBLY
SOMEDAY WILL BE—A FILM ROUGHLY TWO HOURS
LONG, AN INTIMATE, LOW-BUDGET DOCUMENTARY
PORTRAIT OF A MEMORABLE, DEVOTED WOMAN
TO WHOSE NAME THE FILM'S TITLE WOULD
PAY ALL DUE RESPECT. THIS IMAGINABLE FILM
WOULD INSINUATE ITSELF VAGUELY INTO THE
CINEPHILE'S COSMOS ADJACENT TO RAINER
WERNER FASSBINDER'S DOMAIN, SETTLING THERE
VIA THE LOGICS OF HOMONYMY: *THE MERCHANT OF
FOUR SEASONS* (1972), *VERONIKA VOSS* (1981)—
BUT ATTACHED VIA PERVERSITY TO A CHARACTER
TYPE ONLY DRAMATIST ALAN BENNETT COULD
CREATE, A SOLITARY MIDDLE-AGED SUBURBAN
BRITISH WOMAN IN THRALL TO FIXATION.

But for the present, that film—distilled, extracted—lurks embedded within Kutlug Ataman's installation of the same title, and the viewer inhabits it rather than watches it as a moviegoer. Ataman's project is about approaching cinema from another front, taking it by surprise, dismantling it, and, in rebuilding it, recalibrating its relationship to time.

Born in Istanbul in 1961, Ataman, a Turk based in London and Barcelona, graduated with an M.F.A. in film from the University of California, Los Angeles, and despite the global success of his second feature, *Lola and Billy the Kid* (1998)—a gritty melodrama about the lives of young gay and transsexual Turks in working-class Berlin—he has become today identified with an ongoing series of documentary portraits conceived as gallery installations. His debut installation, the 465-minute, single-screen *semiha b unplugged* premiered at the 1999 International Istanbul Biennial, and it set out the general premises

underlying the remarkable succession of gallery-based projects he's produced since then.

In *semiha b unplugged*, Ataman gained the trust of the fabled octogenarian Turkish opera diva Semiha Berksoy, who, with little apparent coaxing, proceeds to narrate her own life story, dressing and undressing in flamboyant operatic finery as she intersperses her monologue with recreations of her greatest triumphs onstage and off. It is, of course, in its scale, her life's most awe-inspiring performance, as the epic accumulation of words—her experiences, her memories, her family's history and her album of lovers, her own sustained fantasia of herself—shadows the evolution of the modern Turkish nation, from the death rattle of the Ottoman Empire into which she was born, to its embattled contracts with secularity by century's end.[1]

In its title, *semiha b unplugged* references MTV's concert format in which famous recording artists perform live, typically an acoustic set, minus the elaborate electronic technologies required for each's unique sound to emerge, and here that takes the form of Semiha Berksoy performing without live accompaniment. But that "unplugged" status also slyly alludes to the piece's marathon duration, unplugged as in unleashed, a performance nearly eight hours long. It would be, in that dimension, unbearable to watch if its producer had approached Berksoy as a fount of folly, or as camp. Instead, the genius of the project lies in the collision of this literally fabulous subject with Ataman as her witness and spectator, inhabiting the guise—albeit sincere and transparent in intent—of fan.

Exhaustingly entertaining, Semiha Berksoy takes her place in a pantheon of such cinematic *monstres sacres* as Big Edie and Little Edie in Albert and David Maysles' *Grey Gardens* (1975), the retired divas of Werner Schroeter's *Love's Debris* (1996), the title character in Andy Warhol's double-screen *Paul Swan* (1965) (who, effortlessly coaxed from obscurity, similarly dons decades-old costumes to recreate semi-forgotten stage specialties), and, most of all, the monumental Winifred Wagner about whom Hans-Jurgen Syberberg constructed the five-hour portrait-interview, *The Confessions of Winifred Wagner* (1975). To compare Semiha Berksoy to the perfect (last surviving) Wagnerian and Hitler-apologist is hardly to suggest any political affinity between the values by which they lead their lives and supported their art; on the contrary, Berksoy, as we see her, remains in her eighties as violently flouting convention for the pure pleasure of the flout. But for Syberberg, the Maysles brothers,

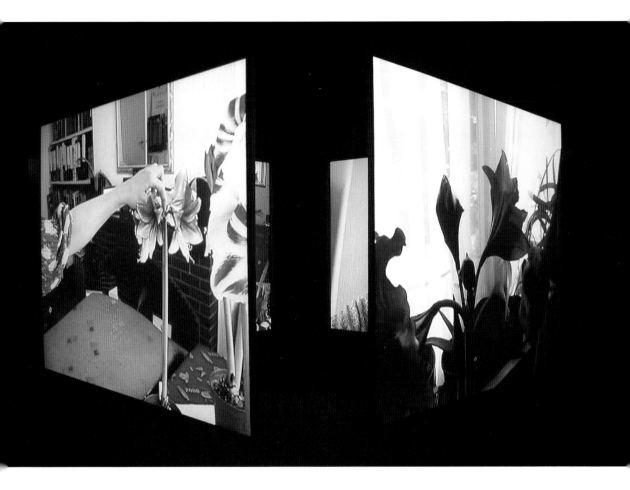

Warhol, and Schroeter, as for Ataman, the aptitude for compelling portraiture is grounded in profound, immovable fascination with the people they behold—and in an absolute disinclination to look away. Hence is born the epic duration, the unblinking gaze.

That attendant ethic of self-effacement is exercised in what remains Ataman's best-known installation, *Women Who Wear Wigs* (1999), which premiered at the Venice Biennale. The piece takes the form of four simultaneous projections, arranged in a row, each revealing an interview with one of the four women of the title. Ranging in length from about forty-five to about sixty

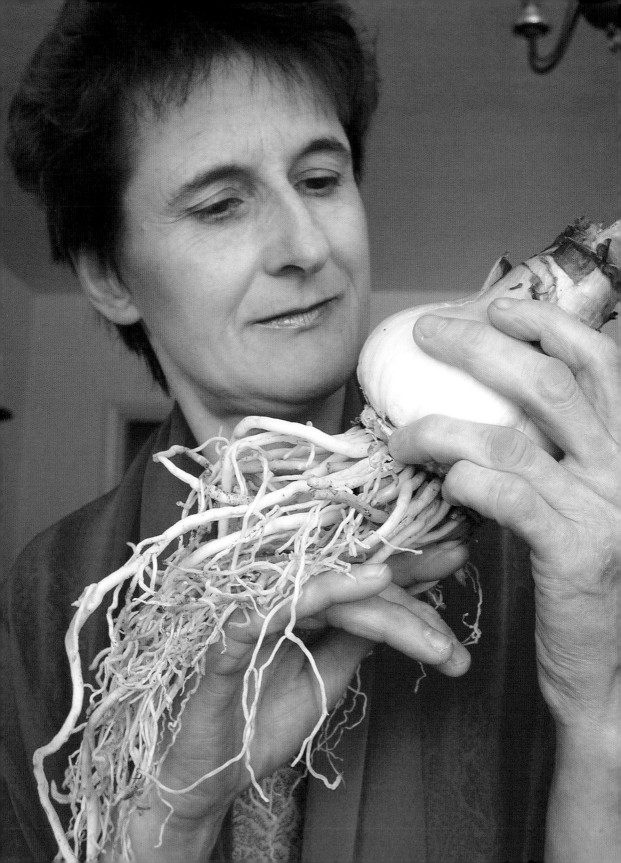

minutes, each portrait becomes in effect the occasion for the speaker to set the ground rules by which she chooses to be represented in societal terms. Ataman's rapport with each of the women and the bonds of trust they feel toward him are nourished by the almost casually hand-held camera, attentive to their stories but at the same time lightly hovering, unobtrusive, with the artist's presence partly inscribed by the subsequent minimizing or deleting from the soundtrack of his own off-camera audible presence, to which the women differently respond. One woman, whose facial identity is only glancingly revealed, tells of adopting a blond wig to avoid detection of her left-wing political activities. Another, a journalist, has taken to wigs as a consequence of chemotherapy for breast cancer treatment. The third woman is never seen at all: over a black background, she tells of using a wig as the head-covering mandated by her Muslim faith, in the absence of being able to use a conventional scarf, which is forbidden to be worn in the buildings of the public university she attends. The fourth is a transsexual prostitute and activist who feels her visual status as a woman is enhanced by a wig.

Unlike the unified focus of *semiha b unplugged*, *Women Who Wear Wigs* compels the spectator to become, herself or himself, also the work's editor and confessor, as each of the four identically-sized projections reveals its own tale of concealment. All shot in Istanbul of Turkish women, the four stories collectively produce, in almost choral form, a brief on the condition of women in contemporary Turkey, a condition organized around structures of conformity and deception, assimilation and self-reliance. The poignancy is carried from the depths of each woman surrendering her secret; the force of that comes from the accumulated, parallel articulation of those secrets, that cunning, and that shame.

Prior to his retrospective at London's Serpentine Gallery in February 2003, Ataman remarked on the quartet of portraits in *Women Who Wear Wigs*: "I only select people who are extensions of myself. I'm drawn to people who broadcast who they are. I like to draw attention to the way identity is formed through talking."[2] Such preexistent affinity is the basis for *The 4 Seasons of Veronica Read*: Ataman first met Read when his own interest in amaryllis bulbs led him to her Spring Show—a kind of open house—she holds each year in her South Harrow home outside London. Professionally, Read is the National Plant Collection Holder of the Hippeastrum (commonly called amaryllis), and her modest dwelling, as rendered by Ataman, has been transformed into a virtual

laboratory for the plant's care, feeding, and survival (its epic antagonists being contagion and mites).

Armed again with a small camcorder and using only available light, Ataman made periodic visits to Read over the course of a year, clearly having won her confidence sufficiently for her to entrust to him the burden and joy of her knowledge. Since antiquity, artists have invoked the rhythms of seasonal passage as a structural device able to accommodate virtually all manner of reflection and commentary touching on the irreducible human verities of birth and death. In constructing the four-paneled *4 Seasons* installation, Ataman explicitly invokes such a seasonal logic: "After all, it spans four seasons, it's cyclical, like the lifecycle of the flower bulbs."[3] Divided into four discrete image channels of varying lengths, one for each of the seasons during which he visited her, the installation favors simultaneity over sequentiality, with the viewer only in the wake of having watched all four screens able conjecturally to follow the arcs of seasonal passage Ataman has witnessed Read weathering.

The installation—or, rather, Ataman's reconstruction of Read's mono-logues—precludes the assurances of closure that would come inevitably if the four segments were shown end to end, in order, single channel—the documentary film immanent in the raw material, "veronica r unplugged." Ataman's central artistic decision in producing the piece thus pivots on his refusal to confer closure on Veronica Read's project of self-construction. In *semiha b unplugged*, he exercised that refusal by force of length, an eight-hour monologue easily exhausting the spectator's capacity for absorption; *Women Who Wear Wigs* sets up four chatty narratives and runs them all at the same

time. In *4 Seasons*, its one speaker is quartered, speaking to herself, with both Ataman and us positioned as intimate observers.

Although in some respects a public figure, Read is defined within the installation as the mistress of her own domestic enclosure, and she exercises goddess-like control, alternately benevolent and ruthless, over the plants she's harbored, passing on, along the way, any number of helpful hints for amateur hot-house gardeners. The grandeur of her devotion is highlighted as she applies the vocabulary of classical tragedy to the realm of botany in her endlessly repeating task of aiding birth ("The veins, the lovely veins!"), combating contagion ("I had death imposed on them"), and anticipating the final chapter ("The culling had to start!") as the life cycles of her charges run their course.

The viewer of the installation experiences the seasons one at a time, or all at once, one screen up close or all four at a distance; Veronica can at any given moment be radiant or demoralized, didactic or pensive, triumphant or abject, but always as triggered by the behavior of her bulbs, so it's a mild shock to the hermetic system when she refers to the world outside—the existence of her mother, for example, or that she once worked with terminal cancer patients. Those rare disclosures join her story's by far most "dramatic" moment, when Ataman off-camera casually asks her if she might be allergic to the very plants to which she's devoted her life, eliciting from her an abrupt silence, followed by an atypically snappish "I don't want to talk about that!"

In the imaginary film version of *The 4 Seasons of Veronica Read*, that exchange would undoubtedly form the narrative climax: our heroine's tragic "secret" revealed, and an "ironic" one, at that. But the logic of the installation maintains its stance against linearity and closure and instead cultivates Veronica Read as herself in perennial-annual flourish.

Notes

1. An active performer as recently as 1999, Berksoy appeared that year at Lincoln Center, in the world premiere of Robert Wilson's *The Days Before: Death, Destruction and Detroit III*.

2. Niru Ratnam, "Kutlug Ataman," *The Observer* (U.K.), December 29, 2002.

3. "Teachers' Notes: Kutlug Ataman," Serpentine Gallery, London, February 11–March 9, 2003.

MATTHEW BARNEY

DRAWING RESTRAINT 7

1993

TAIL CHASER

Helen Molesworth

DRAWING RESTRAINT 7 (1993) IS AN INSTALLA-
TION (ONE WALKS INTO A FABRICATED ROOM
ILLUMINATED A COLD, MEDICINAL BLUE-WHITE
BY FLUORESCENT LIGHTS), A PIECE OF VIDEO
ART (WE SEE A NINE-MINUTE-LONG TAPE LOOP
OF FROLICKING SATYRS), AN INSTANCE OF
RELATIVELY EXTREME AND REPETITIVE PERFORM-
ANCE (AS THE THREE SATYRS DEPICTED ARE
EACH IN IMPECCABLE PHYSICAL CONDITION
AND CONTORT THEMSELVES IN INCREASINGLY
ARDUOUS WAYS), AND A SCULPTURE (FOR THREE
TELEVISION MONITORS HANG SUSPENDED FROM A
CLAW-LIKE MOUNT FROM THE CEILING).

This early piece demonstrates the easy conflation of artistic media that has become a hallmark of Matthew Barney's work; the *gesamtkunstwerk* of his recently completed *Cremaster* series was made possible, in part, by using any means necessary to insure that the message far surpasses the medium. The message, of course, is what has been difficult to decipher all along in Barney's work. His career has been marked by a plethora of reviews that begin and end with discussions of how difficult it is to write about Barney's work. This struggle for an interpretive toehold is alternately used to vilify the work's overwrought and solipsistic meaninglessness or held instead as proof positive of the sublime difficulty and genius of the material to resist our meager art world minds at every turn. The contradictory, but nonetheless simultaneous, difficulty of interpreting the work and the language-bath that accompanies it (the catalogue for the recent Matthew Barney exhibition at the Guggenheim is over 500 pages long) points equally, however, to a lesson taught by that other great silent artist, Marcel Duchamp. The quieter the artist, the more others rush to fill the void. It is no mistake then that Barney's works are largely mute.

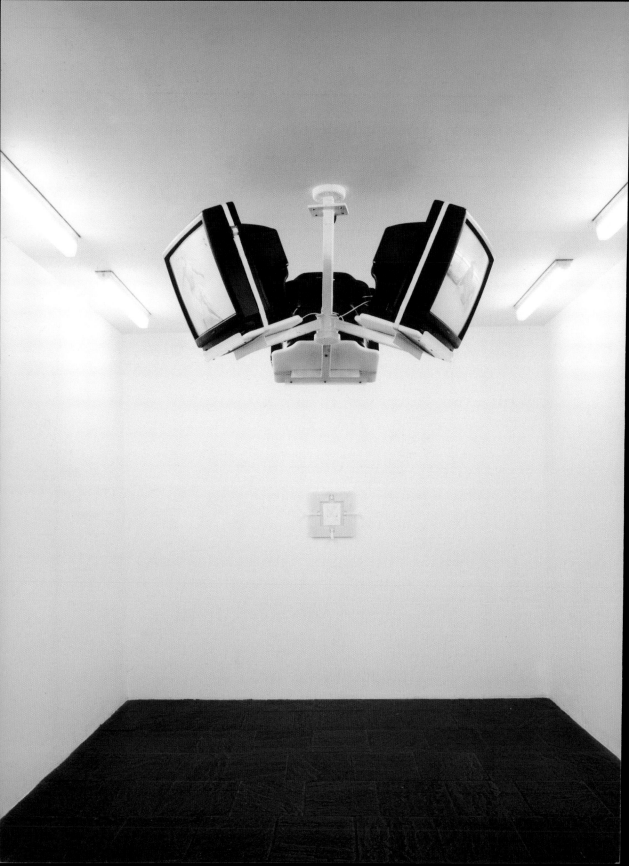

Drawing Restraint 7 was first exhibited in the now routinely vilified 1993 Whitney Biennial. One of the most important biennials in decades, the exhibition brought together works by a then emerging generation of artists concerned with identity, the body, sexuality, and politics. Having rejected the excesses of the 1980s' return to neo-expressionism, and having inherited the radical art experiments of the 1960s and 1970s as so much historical residue, this generation of artists embarked on an exploration of self that was neither specifically autobiographical nor abstractly humanist. Rather, they came to an increasingly shared understanding of the body as a socially constructed vehicle that shaped and contained what was considered most individuated and private, and that understanding provided a dialectical tension that formed the engine for much 1990s' art production. So too the inheritance of performance and body art, single-channel video works, and feminist art as the artistic ground against which artists articulated their work (as opposed to the legacies of abstract expressionism and pop, which informed the previous generation) meant that identity-based work in the 1990s often deployed a set of formal concerns not yet fully received by either a lay audience or the art world itself.

Against this backdrop Barney's practice stood out in the extreme. From his first New York gallery show, in which viewers saw video documentation of (and scuff marks from) a naked Barney using mountain-climbing gear to scale the walls, Barney, and specifically his young, attractive, and sculpted body, received an enormous amount of press attention. Barney's presentation of the body as a sculptural medium, combined with the tension between live action, video documentation, and relics, immediately summoned the oeuvres of artists Vito Acconci, Chris Burden, and the Vienna Actionists. Yet, lest we see Barney as trapped in a mise-en-abîme of art world solipsism, these works were quickly followed with pieces that referenced the mythological realm of Bacchus, as well as the more prosaic contemporary myths of master illusionist Harry Houdini and American football legend Jim Otto. But in each body of work the artistic concerns remained the same: what does an artist do with his body?

Drawing Restraint 7 is part of a larger series of works in which Barney placed self-imposed restrictions on his ability to make an art object, here configured as drawing. Drawing has long been thought the most direct form of artistic expression—a mode of mark making in which mind and body are envisioned as perfect extensions of one another, as line moves effortlessly from the body onto the paper. Process artists in the 1960s and 1970s, however, extended

the definition of drawing to include, among other things, a holistic and arduous use of the body, such that drawings often became elaborate artifacts of physical performances.[1] Barney's spatializing of this mode of drawing invested with new energy the relationship in process art between drawing and sculpture as task and/or performance, residue and/or completed object. This was particularly the case as Barney did not stage these bodily experimentations as exclusively formal procedures. Instead he injected these historical investigations with a series of highly elaborated sexual fantasies, which had remained, if not repressed, certainly dormant in process art.

Drawing Restraint 7 begins as viewers enter an immaculate white cube, distinguished by a hospital-like blue-whitish light, which gives the room a vaguely surgical, antiseptic, and otherworldly feel. Immediately one encounters a triumvirate of monitors suspended from the ceiling. Able to watch only one monitor at a time, viewers can then either circumnavigate the sculptural unit, trying to take it all in, or pause in front of each monitor individually. In the latter case, one usually ends up leaning against a wall with head slightly arched to look up and see the image. What one sees on the monitors is uncanny in its eerie familiarity and seemingly utter newness.

The piece begins with a satyr who ambles into the frame on cloven hoofs with a balletic swagger worthy of cowboys in a spaghetti western. A bowed head shows a close-up of incipient horns: we have before us a youngster. This creature, undoubtedly male, evidenced by the rippling muscles of the nude torso and the practically Dionysian proportions of the arms, is also weirdly gender neutered: the genital area is masked by the costume, rendering it as a kind of undifferentiated lumpy mass. The young satyr proceeds to writhe and flail on the floor, moving his body in a perfect circle in a vain attempt to catch his own tail. The athletic physicality of the movement evokes the performance drawings of William Anastasi, as well as movements found in Yvonne Rainer's exaggerated, task-based dance and Bruce Nauman's studio performances. Yet such art world references do little to mitigate the strange feeling produced by watching this futile animalistic game. We share the fleeting satisfaction of the satyr when he briefly manages to touch his tail, only to watch that pleasure quickly transform into aching frustration—a tension of waiting and release that is consummately sexual. Are we to understand this tension as part and parcel of artistic process as well? Is chasing one's tail here a metaphoric or literal endeavor?

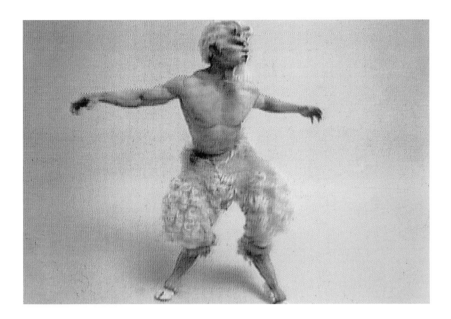

No sooner than such interpretive questions arise, the scene is cut with several frames of bright white light. In this space of fantasy there shall be no fade-to-black. Next we encounter a grown satyr, complete with grotesquely hairy legs, full grown horns, and billy-goat beard. The sheer vitality and strength of the male torso is even more exaggerated. We see before us a "young buck"—a stock Hollywood character to be sure, despite the costume of classical mythology. Watching this satyr begin his solitary frolic we feel the overwhelming power and self-fascination of youthful suppleness. This is a body whose energy lies in its mutability rather than its lived experience. This is a creature of the present. Now that we've been introduced to our central characters—the boy satyr and the young buck—the true staging of the work can begin. We watch as two of the young buck satyrs laugh and wrestle with one another in the back seat of a limousine, which glides, self-propelled, over bridges and through tunnels around New York City.

Satyrs are mythological creatures—half man, half goat—who are the notoriously lazy and lecherous attendants of Bacchus. Their hallmark activities include unruly behavior, drunkenness, and rape. Known to chase after nymphs,

they personify both evil and lust. It is telling that nymphs are entirely absent from *Drawing Restraint 7*; indeed, the satyrs' rollicking laughter in the back of the limousine easily evokes a current manifestation of the species: the American fraternity brother. As the satyrs battle in the back seat, one tries to use the horns of the other to make a mark in the condensation on the car's sunroof, as artistic mark making is reduced to homosocial sport. In the front seat, the younger satyr continues to try and catch his own tail, although now he slides effortlessly in between the seat cushions in a repetitive circular action that suggests all sorts of extrusions from and entrances into the body. These two performances—one homoerotic, the other onanistic—are both generally arousing (in the most polymorphously perverse way) and specifically repugnant (not even Matthew Barney can make frat boys look good). The loop ends with the young satyr once again briefly touching his tail and one of the paired young bucks breaking the horn off his opponent. The last frame shows a triumphant image of a satyr standing proud, one hoof resting upon the stripped horn.

For all of the perversion, for all of the dynamics of sexual pleasure, for all of the boundary-defying antics—in which the distinctions between artistic media and the differences between man and beast are all but erased—the vision of *Drawing Restraint 7* is nonetheless bleak. Artistic mark making is either a largely futile activity punctuated by fleeting moments of animal pleasure, or it is bound up with the culture of trophies, in which the struggle to make a mark has as its inherent structure the erasure of the other. Similarly, playing with polymorphous perversion and gender weirdness results in something profoundly solitary: either one is alone in a spiral of self-frustration or one is alone through a denial of the other. Caught in the harsh white light of the installation, the viewer is left only with her back to the wall.

Notes

1. See Cornelia Butler's important exhibition catalogue, *Afterimage: Drawing through Process* (Los Angeles: The Museum of Contemporary Art and Cambridge: MIT Press, 1999).

DRAWING
RESTRAINT
7

TACITA DEAN

FERNSEHTURM

2001

OF CLOCKS AND CLOUDS
Bruce Jenkins

WHAT PRIVILEGES TACITA DEAN'S FILMS AMONG
THE ROBUST FIELD OF CELLULOID—FRIENDLY WORK
PRODUCED BY CONTEMPORARY ARTISTS IN RECENT
YEARS IS THE DEGREE TO WHICH THEY HAVE
ATTENDED TO A SPECIFIC SET OF AESTHETIC
AND IDEOLOGICAL ISSUES THAT FUELED EARLIER
ARTIST-PRACTITIONERS OF THE MEDIUM—THAT
IS TO SAY, THE DEGREE TO WHICH THE WORK
CAN BE UNDERSTOOD AS AN ELABORATION OF
AN ARTISTIC PRACTICE THAT ATTENDS TO THE
SPECIFICITY OF CELLULOID AND ITS SINGULAR
TEMPORAL AND SPATIAL CHARACTERISTICS.

The earliest filmmaker-artists, Fernand Léger and Marcel Duchamp in France or Hans Richter and László Moholy-Nagy in Germany, took cameras in hand and set out to explore what this new medium could render that a paint brush or chisel could not. Later, they would become the models for a heterogeneous group of artists, on both sides of the Atlantic, who would reimagine a cinema not merely "artistic" in its execution but a tool for the execution of contemporary art. Though largely forgotten, the history of this "other" cinema finds itself reinvigorated in Dean's art—and perhaps nowhere more so than in *Fernsehturm,* a film installation that in the plenitude of its aspiration reconnects the mechanized procedures of the moving image to the very contours of the human experience.

Shot in the fall of 2000 and completed in 2001, *Fernsehturm* might easily be read as a self-consciously millennial work. Set within a rotating restaurant atop the television tower referenced in the film's title, which rises above Alexanderplatz in the former East Berlin, the film creates a sidewise perspective that in many ways rivals the aerial views offered by the overtly millennial London Eye, a Ferris wheel that was erected on the banks of the Thames for the year 2000 celebrations and yielded vertiginous images of the adjacent city. While *Fernsehturm* certainly

can sustain and repay such readings, the precision of its design and realization open onto more complex cultural, political, and aesthetic matters.

The simplest description of Dean's film—a circular tracking shot[1] from within an architectural edifice—immediately conjures up two canonical works of an earlier cinema: Andy Warhol's *Empire* (1964) and Michael Snow's *Wavelength* (1966–67). Yet like the continuous circular shots that dominate the work, the intertextual richness of *Fernsehturm* seems to resist closure as it radiates back and forth from the margins of cinema—revisiting the proto-filmic optical toys of the late nineteenth century and shuttling forward, from the architectural-cinematic articulation of the Eiffel Tower in René Clair's *Paris qui dort (Crazy Ray)* (1923) to the leading edges of contemporary practice.

From a structural perspective, we can recognize *Fernsehturm* as the record of a cybernetic encounter of one machine with another. It is this aspect that most directly invokes the experience of Warhol's *Empire*, in which the artist's film camera idly gazes upon the creeping advance of nighttime over the façade of upper portions of the Empire State Building.[2] Shot over a six-hour period from just before sunset into the early morning, Warhol's film enacted a series of radical reductions that reverted the cinematic apparatus to its historical origins in the motionless, black-and-white, silent "actualities" of the late 1890s, a formal maneuver enhanced by the artist's decision to project the finished work at "silent speed," which lengthened the projection time to eight hours and introduced the visible flicker often associated with silent cinema.[3]

While her choice to document an architectural edifice across time creates intertextual links to Warhol's film, the manner in which Dean presents that space bears closer resemblance to Michael Snow's *Wavelength*. Shot over the course of a week in December 1966, Snow's film consisted of a series of static and zooming shots that gradually traversed the expanse of the artist's lower Manhattan loft, shifting slowly and unsteadily from a long shot of the entire expanse of the space to an extreme close-up of a photograph of the ocean affixed to the far wall. Over the span of its forty-five-minute running time, *Wavelength* records not simply the narrowing of the visual field but also what Snow describes as "4 human events, including a death." In a radical reversal of the expository procedures of normative cinema, however, these narrative actions remain peripheral to the work's formal design and to Snow's attempt to create what he termed "a time monument in which the beauty and sadness of equivalence would be celebrated."[4]

Andy Warhol
Empire, 1964

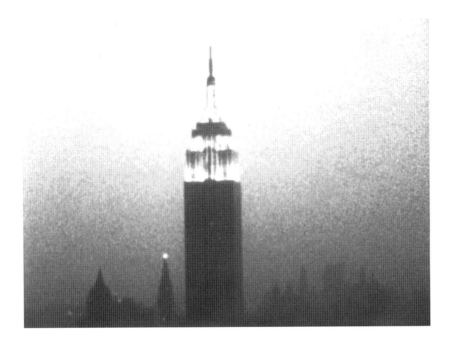

Tacita Dean's *Fernsehturm* might also be considered a time monument, and a work that manages to spatialize time through a metonymic gesture—a spiraling through time—that bridges the seemingly incommensurate strategies at work in *Empire* and *Wavelength*. Like the former, the film captures the cycle of day to night and the transformative effects of light on both nature and the built environment. Like the latter, it utilizes a distinctive cinematic effect (circular movement in place of Snow's zooming) both to traverse an interior space and to render that journey in a manner that opens up onto social and cultural concerns.

● ● ●

Fernsehturm is a 16mm, anamorphic (wide screen), color film with a running time of forty-four minutes, installed as a continuous projection on a fourteen-foot-wide screen in a neutral gray gallery space. Shot in October 2000, the finished film consists of thirty-four shots ranging in length from a few seconds

to more than eight minutes. The majority of shots present a wide-angle view of the tower's revolving restaurant-cum-observatory, with the camera positioned on the rotating platform on which the tables are set. The circular movement that results has a slightly uncanny quality, since the expanse of décor in the middle ground (which includes the restaurant's furnishings, wait staff, and customers) remains unchanged while the sky and distant cityscape visible through the windows is set in gradual, but continuous, motion. Occasionally the camera is placed on the non-moving central service area and, in these instances, the customers seated at their tables seem to float past as if on a carousel. Overall, the film is organized chronologically and records the activities of a single day's (business) cycle.

Early in the film, as customers begin to arrive, Dean employs a standard device of continuity editing so that several people who pass very close to the camera as it faces the service area are seen in the next shot advancing toward the rear of the restaurant. This sense of continuity is enhanced several shots later by an extreme long take, an eight-minute shot taken from the opening camera position that traverses nearly a quarter of the restaurant's curvilinear space and concludes as the light begins to fade into late afternoon. As the sun begins to set, the patrons become silhouetted against the still-bright window panels. People drink, smoke, chat, and occasionally gesture toward distant sights. There are inaudible murmurs of conversation, the clanking of food and drink service, and—coming on about two-thirds of the way through the work—the sound of a keyboardist performing with synthesized accompaniment. Dean is careful to continue his songs over her cuts (part of the continuity system again), and as the circular track continues its path, the musician and his console come into view with the last rays of sunlight streaming through the windows.

The balance between the illumination of the inside and outside begins to shift and with it the direction of light. Against a nighttime sky, the windows reflect back portions of the restaurant interior. The room darkens, and the patrons are now situated in small pools of light emanating from table lamps. With less visual content, the shot lengths become shorter. As the camera continues its circular course around the restaurant, the keyboardist can be heard performing his rendition of Johann Strauss's "The Blue Danube."[5] Shortly thereafter, the house lights are turned on and the remaining patrons efficiently leave the restaurant. The work, quite literally, returns to its

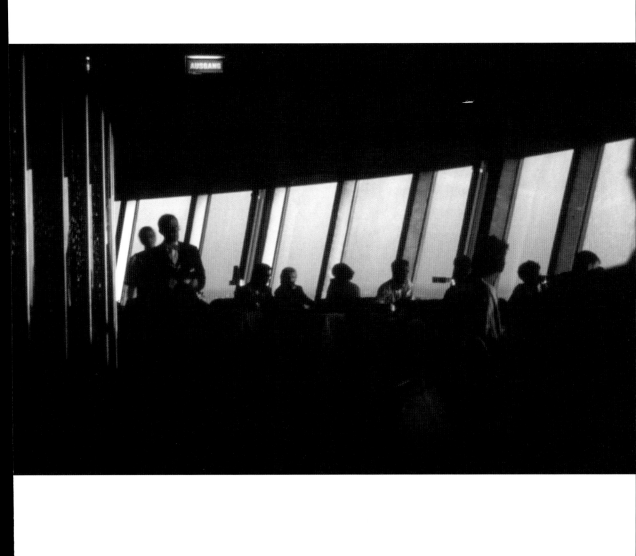

opening scene as waitresses clear and reset the tables and begin to leave. The screen fades to black.

• • •

In deploying her series of circular images continuously, Dean has responded to a fundamental structural feature of the building itself. As German critic Friedrich Meschede has noted, the Fernsehturm "has the geometric form of the sphere, a perfect form without beginning or end, and one which, at this height, affords a prospect which is similarly infinite."[6] The cycle of the revolving observational platform mimics the cycle of the planet's rotation and suggests a series of productive resonances that can help us to understand the film.

FERNSEHTURM

 The spatio-temporal flow of the film, with its continuous deferral of an endpoint and sense of cyclic return, unmistakably evokes Julia Kristeva's celebrated analysis of "women's time"—"a specific concept of measurement that... retains *repetition* and *eternity* out of the many modalities that appear throughout the history of civilization." The former term condenses for Kristeva a sizable portion of human experience, including "cycles, gestation, and the eternal return of biological rhythm." It is this aspect that she associates with "resplendent visions and unnameable jouissance," a description that vividly captures what must be the fundamental appeal of the tower for its patrons.[7] Yet while both the film viewers and the filmed viewers experience the pleasures of repetition—the cycles, the eternal return—"we," from our perch as spectators of a constructed portrayal of these cycles, experience as well the other mode that Kristeva calls "eternity." Dean's film is able to articulate the larger arc of temporal experience that is unavailable through the lived experience of the building alone.

 Dividing the experience of the film viewers from the experience of the filmed viewers is a crucial step in probing the work. For while there are two divergent modes of temporality at play in this film, there are equally two divergent spatial experiences. The lived experience of the Fernsehturm tower is a contemporary version of that early novelty of cinema exhibition know as Hale's Tours, in which spectators sat in mock railway carriages adjacent to a screen on which film shot from moving trains was projected.[8] The filmed experience of the Fernsehturm tower, however, creates a second level of spatiality for the film viewer/gallery goer, who, as it were, enjoys a Hale's Tour of Hale's Tour. That is to say, the spectator is consciously placed at a distance,

one remove from the "authentic" kinesthetic experience but privy to a specially constructed moving-image experience that is possible only through the mediation of Dean's camera.[9]

The relationship between the cinema and travel suggests other specific resonances as well. The focus on the city of Berlin itself entails a history, and in particular a moving-image history. Berlin, after all, was the birthplace of the "city symphony," whose name and formal characteristics were devised by Walther Ruttmann for his 1927 urban portrait, *Berlin, Symphony of a Great City*. Here was the origin of the day-to-night cycle, of a montage based on architectural features and the flow of people and machines across the cityscape, and of a musical score that closely corresponded to the pace and rhythms of urban life. Ruttmann might have admired the architectural and engineering prowess that engendered the television tower and allowed Berliners of a new millennium to so efficiently partake of the metropolis's visual splendor.[10]

In the end, however, the resonances that radiate from Dean's simple but rigorous work find their most sublime resonance in the work of a group of young British artists of the 1960s and 70s who attempted to create an art of "cinéma pur,"[11] structuring their work with predetermined schemas to explore the aesthetic parameters of the medium. Chris Welsby, for example, described the variables he used to structure his film *Cloud Fragments* (1978)—clocks and clouds. For Welsby, the "'clocks' represented certainty and the more rational, mechanical aspects of things": a list that included both the givens of his technology ("cameras running at twenty-four f.p.s. and tripods with their mechanically controlled functions") as well as aspects of the urban environment ("trains and busses running to timetables...or architecture with immediately definable proportions"). By contrast, the "clouds" represented "those things which cannot easily be measured or predicted: irrational, unknown quantities like "wind, cloud, changing light conditions, the movement of animals and to some extent people."[12]

Dean's, too, is a cinema of clocks and clouds—where a mechanized frame of vision (created by the camera) and a mechanized architectonics (created by the tower) conspire, like the microscope and the cyclotron, to unlock the ineffable secrets of time and space, of light and movement, of human interaction with the natural and constructed environment.

Notes

1. I use the term "tracking shot" to describe the basic spatial articulation that Dean captures with her camera, despite the fact that the camera itself remains static on a platform in the revolving restaurant of the building. The tracking motion derives wholly from the rotation of the platform on which the camera stands. Although Dean does not make "movements" with her camera, this kind of "tracking shot" is very similar, in fact, to the kinds of shots achieved in early cinema, where the tracking motion was imparted by a stationary camera mounted atop a moving vehicle (train, boat, trolley).

2. Dean's choice of edifice is a building, like the Empire State, that was designed to serve both a utilitarian function and an ideological one. Originally designed for a less prominent site in East Berlin, Fritz Dieter and Günther Franke's Fernsehturm was eventually plopped down in the center of Alexanderplatz, where it became an iconic intervention within a historic urban plan and loomed over the geographic center of the former capital in full view of the citizens of both the East and the West. The aspirations of its clients—the German Democratic Republic—were reconfirmed when after four years of construction the building was opened in October 1969, on the twentieth anniversary of the founding of the GDR. A tourist destination as well as a favorite hangout for the East German Stasi, the restaurant not only commanded an astounding panoramic view of both Berlins but quite literally concretized the State's political aspiration to perpetuate the people's "revolution."

3. For a more complete analysis of Warhol's *Empire*, see Callie Angell, *The Films of Andy Warhol: Part II* (New York: Whitney Museum of American Art, 1994), pp. 15–18.

4. Michael Snow, quoted in *Film-Makers' Cooperative Catalogue No. 5* (New York: The New American Cinema Group, 1971), p. 299.

5. "The Blue Danube," most notably used in the Orion and moon shuttle sequences in Stanley Kubrick's *2001: A Space Odyssey* (1968), is here purposefully downplayed, accompanying darkened images in contrast to the spectacle of the Kubrick. It nonetheless creates an unavoidable cinematic, historical, and architectural allusion in the context of the slowly rotating restaurant, a futuristic design made at the same moment Kubrick was creating his futuristic space odyssey.

6. Friedrich Meschede, "Fernsehturm," trans. Helen Atkins, in *Tacita Dean* (London: Tate Gallery of Modern Art, 2003), p. 50.

7. Julia Kristeva, "Women's Time" (from *New Maladies of the Soul*, 1977), in *The Portable Kristeva,* ed. Kelly Oliver (New York: Columbia University Press, 1997), p. 352.

8. Premiered by its inventor, George Hale, at the 1903 St. Louis Exposition, the "Tour" included travelogue narration and a clanging train bell, and the entire screening space rocked to mimic the motion of a train car. For a more complete account of Hale's Tours, see William K. Everson, *American Silent Film* (New York: Oxford University Press, 1978), p. 20. Everson notes that the one country in which this form of film exhibition continued, decades after its demise in the U.S., was Great Britain.

FERNSEHTURM

9. Hale's Tours is not the only early cinematic curiosity to which Dean's film might be compared. Friedrich Meschede has described how the vertical window panels in the Fernsehturm's restaurant are reminiscent of "a strip of film," with the "vertical divisions between the windows" functioning like frame lines. (See Meschede, "Fernsehturm," p. 51.) While an accurate observation and one in line with other cinematically reflexive aspects of the film, this reading of the windows and partitions is superseded at times by a more vivid cinematic, or rather proto-cinematic, reference. In the shots in which Dean's camera is placed on the central (and fixed) service area, an image of the restaurant emerges that is highly suggestive of the early optical apparatus known as the zoetrope. Designed to animate sequences of drawn or photographed actions (a running man, a trotting horse, a flying bird), the device spun (like the restaurant platform) on a horizontal plane and utilized narrow vertical apertures through which to view these subjects in motion. At such moments, Dean has transformed the architecture of a modern high-rise tower into an optical toy—reversing the position of the viewing subjects, who are now inside the apparatus.

10. For a more complete analysis of Ruttmann's film, see Scott MacDonald, *The Garden in the Machine* (Berkeley, Los Angeles, and London: University of California Press, 2001), p. 411.

11. "Cinema pur" was most notably achieved in the brief work of René Clair's brother, Henri Chomette, and his exquisite *Cinq minutes de cinéma pur* (1925–26).

12. Chris Welsby, in *Film As Film: Formal Experiment in Film 1910–1975* (London: The Arts Council of Great Britain, 1979), p. 150.

ANDREA FRASER

LITTLE FRANK AND HIS CARP

2001

LITTLE ANDREA
George Baker

WHERE DOES A *PARERGON* BEGIN AND END.
WOULD ANY GARMENT BE A *PARERGON*.
G-STRINGS AND THE LIKE.

—Jacques Derrida, *The Parergon*

For those familiar with Andrea Fraser's early projects, the turn represented by her work in the last three years can only be immensely confusing. Producing large- and small-scale video "pieces," often for exhibition and sale in commercial galleries, Fraser seems at least partially to have abandoned her commitment to what she herself calls "hard-core" institutional critique explored in earlier project-based work. Instead, in a magnification of her performative presence in her first projects—*Damaged Goods Gallery Tour Starts Here* (1986), or *Museum Highlights: A Gallery Talk* (1989), for example— we are treated to piece after piece focusing relentlessly, if not narcissistically, on Fraser herself: the samba-dancing of *Exhibition* (2002), the revolutionary posing of *Soldadera* (1998/2002), the faux-inebriation of *Art Must Hang* (2001), the transgressive exhibitionism of *Little Frank and His Carp* (2001). A sympa- thetic reader might propose a logical transition here, from Fraser's early desire to critique the art institution as in some way a subject (through psychoanalytic and sociological methods), to a new project that will dialectically treat the artistic subject now as itself an institution.[1] Less sympathetic readers speak instead of selling out, a self-spectacularization worthy only of the most oily characters from the artistic past: Jeff Koons, perhaps, or Julian Schnabel or Mark Kostabi.

Let me suggest that we narrate the current development of Fraser's work in the following way: Fraser's early projects considered the self-contained work of art as a surrogate, and consequently moved away from such productions to engage the social relations that art covered over, the relations embedded and displaced within art and its institutions. Ultimately, the form of Fraser's early work was to engage the form of social relations themselves. What we now witness in Fraser's self-contained video and film pieces, rather, is that the forms of relationality that she previously discovered are being inserted back

LITTLE FRANK AND HIS CARP

Andrea Fraser
*Museum Highlights:
A Gallery Talk*, 1989

into the work and the normative institutions of art, no longer to frame but to be framed by them.[2] It is in this way that we can understand, for example, the excessive performance of desire on Fraser's part in *Little Frank and His Carp*, a work where an "over-receptive viewer" (in John Miller's words) inherits the model of the wildly-opened subjectivity first drafted in the "characters" of Fraser's earlier critical performances, woven together from a congeries of social and institutional sources.[3] To place the forms of relationality, forms that Fraser discovered only by abandoning the self-contained work of art, back into a work of art is, of course, a logically and perhaps ethically contradictory move. But it is a move that we recognize as that form of incompatibility and contradiction that Fraser has for a long time called "grotesque," the effect of which her recent work thus only amplifies. For Fraser, the effect of the grotesque is "produced by the superimposition of two irreconcilable fields of interest and practice."[4]

In *Little Frank and His Carp*, Fraser had herself filmed with hidden cameras as she enters the lobby of Frank Gehry's architecturally spectacular Guggenheim Bilbao, requests an audio-guide to the museum, and begins explicitly to follow its instructions. The use of hidden cameras relates Fraser's video to the now ubiquitous social forms of "reality" television and surveillance footage, while the surreptitious performance thus recorded harks back to previous art historical examples of performative interventions such as Adrian Piper's *Catalysis* series. Following the audio-guide's instructions, Fraser smiles resplendently when told by the guide that the museum is "uplifting. It's like a gothic cathedral." She presses her hand against her chest when informed that the museum's central atrium "works like a heart, pumping the

visitor around the different galleries." She looks puzzled when told that in the "great museums of previous ages," rooms were laid out in linear arrangements so that one had to visit them all, and it felt as if there was "no escape." She looks relieved when informed that "here there is an escape." She frowns upon being informed that "modern art is demanding, complicated, bewildering." And then she smiles once more, resplendently, upon being assured that "the museum tries to make you feel at home, so you can relax and absorb what you see more easily." Her smile grows, and then grows ambiguous, perhaps guilty, as she is pointed to the museum's "powerfully sensual" curves. Invited by the guide to touch them—"You'll see people going up to the walls and stroking them [the only people Fraser sees going up to the walls and stroking them are carrying audio-guides]...You might feel the desire to do so yourself"— Fraser begins to do so. Carried away by what she is told is the building's "warmth, its welcoming feel," Fraser then gets carried away. As the guide continues to speak about the building, its construction techniques, and its architect's childhood memories, Fraser continues to touch the museum wall, eventually rubbing her entire body against it. She pulls up her dress. She

Allan McCollum
Plaster Surrogates,
1982–83

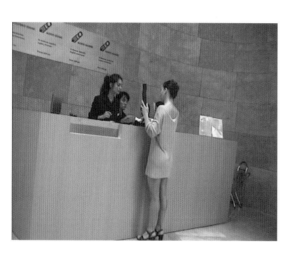
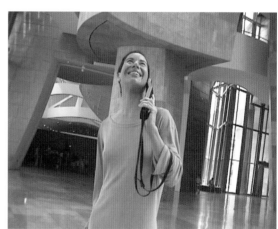

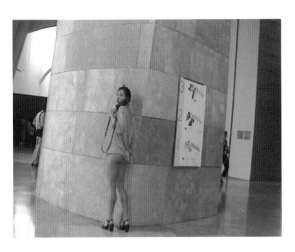
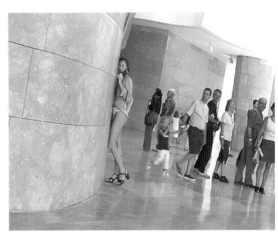

shows off her white thong. She rubs her ass. A small crowd gathers. She dry humps the sensually curving wall.

Speaking about her early docent tour performances and her elaboration then of an alter ego/docent named Jane Castleton, Fraser once asserted: "As Jane Castleton, I articulate what the museum wants. But against this museum discourse, I want to introduce what Jane wants, what I want; specifically, the point at which it exceeds what the museum promises, or takes it too literally, or takes herself as its object."[5] Taking the museum's desire "literally" and taking "herself as its object" might continue to be an accurate description of Fraser's *Little Frank*. It is a strategy to which she has devoted much reflection. In an early essay on Allan McCollum, Fraser suggested that McCollum's blank and endlessly repetitive surrogates, art objects from which all traces of creativity have been withdrawn, might be comparable to the worker's resistance strategy called "working to rule." A minimum performance of what one is required to do, working to rule allows laborers to "transform a strict adherence to factory discipline into a much more radical transgression: that of collectively refusing to freely, willingly, invest their labor in work to the profit of their employers."[6] In *Little Frank*, Fraser's slavish following of the audio-guide's pronouncements might seem a performance conducted itself in relation to the conditions of "working to rule." And yet at every turn, and especially by the work's end, Fraser's adherence to the audio-guide's commands results not in the disidentification and disinvestment with the "employer" promised by working to rule, but in an ever more intense identification with the institution. Fraser follows the museum's injunctions, only to produce effects that they were never intended to allow.[7] She becomes a subject given over ardently to what psychoanalysis would call "transference," displacing affect from a (psychically) real to a surrogate object, in this case not the analyst but the undulating museum walls.

Transference had been the dynamic that Fraser's early performances had intended to engage and yet to disrupt, and so the reversal of that project needs to be registered here. No longer an alignment of the avant-garde artist's performance of negation and refusal with the museum docent's communication and voluntary service, Fraser's *Little Frank* now aligns her position with that of the museum visitor or the public. The former layering produced a performance of schizophrenic (perhaps elitist) difficulty; the latter seems now to result in one of spectacular (perhaps popular) transgression. No longer presenting a

complex script constructed from appropriated language usually taken from outside the realm of artistic discourse, Fraser now simply appropriates the Guggenheim Bilbao's own self-presentation on their actual audio-guide. No longer choosing to displace away from art objects to speak digressively in her docent tours of other things, Fraser stands back as the museum now already displaces away from discussing art to turn narcissistically to itself and its architect/ure. No longer seeking social or desiring relationships as these exist in excess of their rigidification in the work of art, Fraser obeys as the museum now directly commands a social or desiring relationship, even if it is to itself. And no longer disrupting the hidden transference between the museum and its public, Fraser creates an echo of the transference that the museum openly admits is now crucial to its identity or its form. For we listen along with Fraser as the museum happily recalls the childhood reminiscences of "Little Frank" Gehry, pointing us to memories of shopping for fish with his grandmother, an experience of affect so intense that it cannot help but erupt into the fish-inspired forms of Gehry's current architectural fantasias. "The architect," we are told, "has always found inspiration in fish. He dates this obsession from the days when he used to go with this grandmother to market to buy a live carp which he would then take home and keep in the bathtub until it was time to cook it. Here little Frank would play with the carp and here the magic of its sinuous, scaly form somehow entered his bloodstream." We watch as Little Andrea only echoes this transference, throwing herself at Little Frank's carp with all the power of transference's infantile regression.

In this, *Little Frank and His Carp* becomes what Fraser calls a "catalogue" of current "museological seduction."[8] It also becomes a form of what Fraser calls the "grotesque." For the layering of incompatible positions that has long lain at the basis of Fraser's project now seems to be a more generalized historical condition, appropriated as if from the artist by the museum itself. Indeed, more directly, the Guggenheim Bilbao seems to point to the contemporary museum's appropriation of the position of and desire attached to the artist, to his or her "freedom," "transcendence," and "sensuality."[9] And in the face of this grotesque, in part displacing through imitation her own former strategies, Fraser seems to have no choice but to increase the contradictions put in place by her own project, to bring the grotesque to a place where it has never before been.[10] We are left not with the certainties that we once thought came from "critical" artistic practice, but only with a spiraling series of questions. If, in

Fraser's exploration, the contemporary museum has appropriated the position of the "artist," and the artist then appropriates that of the "public," is *Little Frank and His Carp* ultimately not about the museum at all, but about the displaced love cycling between the artist and the larger public? Is this what Fraser's displaced exhibitionism relentlessly figures, as we watch a self-display that potentially awakens and seduces our desire for the desire for sensuous freedom performed in the video? And the twists and turns of this question only become potentially more grotesque. Does the layering of positions unmasked in *Little Frank and His Carp* figure instead the contemporary situation of the confrontation between the "artistic museum" (the museum that appropriates the position of the artist) and the "public artist" (the artist who articulates the experience of the public)? Does the piece display the grotesque aspect of their current inter-relation? Can we now think in the face of Fraser's video the following disturbing set of thoughts: Is not what the artist loves (narcissistically) in the museum in fact its usurpation of the position of the artist? And is not what the museum demands (sadistically) from the artist her usurpation of the position of the public, indeed the popular? These are just some of the questions that now arise from a strategy not of critical "certainty"; they arise from the contradictions and incompatibilities of a form that has become truly grotesque.

LITTLE FRANK AND HIS CARP

Notes

1. Such a bifurcation of critical projects extends back in the history of the avant-garde to the moment at least of dada, with Marcel Duchamp's deployment of the readymade to reflect upon the relation to institutional frames and Francis Picabia's simultaneous use of the mechanomorph to register the objectification of the creative subject.

2. We might also posit here a reaction to the institutional promotion of what is being called the "relational aesthetic," promoted originally by the current director of the Palais de Tokyo in Paris; see Nicolas Bourriaud, *Relational Aesthetics* (1998), trans. Simon Pleasance and Fronza Woods with Mathieu Copeland (Paris: Les Presses du réel, 2002).

3. For Miller's description, see his essay "Go For It," published in German in *Texte zur Kunst* no. 46 (June 2002). This quotation is from the original manuscript in English.

4. This citation is from an as-yet-unpublished work description of Fraser's *Exhibition*, written by the artist for her forthcoming retrospective catalogue to be copublished by Kunstverein Hamburg and DuMont Buchverlag in Cologne in 2003.

5. Fraser interviewed by Joshua Decter, "Andrea Fraser," *Flash Art* vol. 23 no. 155 (November–December 1990), p. 138.

6. Andrea Fraser, "Creativity = Capital," in *Allan McCollum,* the catalogue of an exhibition held November 11–December 11, 1988, at Portikus in Frankfurt am Main and December 16, 1988–January 29, 1989, at De Appel in Amsterdam (Cologne: Walther König Verlag, 1988), p. 14.

7. In this, Fraser's recent work continues a long-standing dialogue with the thinking of Michel Foucault; perhaps the transition from Fraser's early institutional performances to her more recent work could be elucidated by looking to the difference in Foucault's approach both to institutions and discourse in his own transition from an early work such as *The Order of Things* to his late project *The History of Sexuality.*

8. Again, this is from a work description of *Little Frank and His Carp* written by Fraser for her forthcoming Hamburg catalogue.

9. Allan McCollum once described the displacements and fantasies attached to the social position of the artist in the following way: "Well, you know it's very important to us that our artists be powerless, like children. The artist is elected to articulate subjectivity for the culture at large, and we require that that subjectivity be passive, and voyeuristic, without effect. All passions which might feed into any desires to disrupt order are displaced into 'artistic' expression. The way we characterize the 'artist' in our culture—it's a clue to how we construct our emotional lives with regard to the social whole, I think. While we attribute many 'positive' features to the artist, we also attribute a whole set of complementary 'negative' ones. An artist may be spontaneous, expressive, idealistic, sensitive, creative, sensual, and brilliant—but he or she is also neurotic, infantile, self-centered, sexually obsessed, impractical, parasitical, and so forth. It's easy to see how the popular mind imagines that the positive traits necessarily imply the negative ones! Sensuality leads to hypersexuality, idealism to ineffectiveness, expressivity to infantilism, and so on. The artist's character is like an object lesson to most people, a walking argument for moderation in all things. I think people sometimes choose to be artists because they desperately need to play this privileged, doomed role. It's kind of like being a human sacrifice, but without any such cathartic reward!" See D. A. Robbins, "Interview with Allan McCollum," *Arts Magazine* (October 1985), p. 43.

10. Fraser claims that her recent turn to video projection (she has long used video in a documentary, monitor-based mode) was motivated by two things: the commencement by museums of using videos to promote themselves and the appropriation of the "artist" and his or her "life-style" that this turn connotes: "That's what made video projection available to me according to my critical model. I wouldn't project video for effect. But I can appropriate video projection as an institutionalized form…video projections also belong to rock concerts and corporate presentations and advertising and sports events, not just to art. They have a generalized cultural currency, which the art world now uses. For corporatizing museums, video installations provide spectacle, sure. But it's also, in many cases, specifically the artist who is spectacularized, or a body that serves as the artist's proxy, or the artist's 'life-style.' So very often it's not only about providing the institution with spectacle. It's also about projecting an increasingly commodified and de-realized representation of the artist and, once again, of artistic freedom." See the interview of Fraser by Bennett Simpson, "Fantasies of the Knowable Object: An Interview with Andrea Fraser," *Purple* (May 2002), p. 145.

PIERRE HUYGHE

THE
THIRD
MEMORY

2000

THANKS FOR THE MEMORIES
Hamza Walker

IT IS SOCIETY AND NOT TECHNOLOGY THAT
HAS MADE CINEMA WHAT IT IS. CINEMA COULD
HAVE BEEN, HISTORICAL EXAMINATION, THEORY,
ESSAY, MEMORIES.

—Guy Debord[1]

Turning to the raw materials themselves, it is worth taking a passing glance at what Dog Day Afternoon *did not become. Ours is after all a period and a public with an appetite for the documentary fact....We find a particularly striking embodiment of this interest in a whole series of recent experiments on American television with the fictional documentary (or docudrama)....We would have understood a great deal if we could explain why* Dog Day Afternoon *fails to have anything in common with these fictional documentaries, which are far and away among the best things achieved by American commercial television, their success at least in part attributable to the distance which pseudo-documentaries maintain between the real-life fact and its representation. The more powerful of them preserve the existence of a secret in their historical content, and, at the same time that they purport to give us a version of the events, exacerbate our certainty that we will never know for sure what really did happen.*

—Frederic Jameson[2]

On a hot, August afternoon in 1972, John Wojtowicz attempted to rob a Brooklyn branch of the Chase Manhattan Bank. Wojtowicz's stickup was not simply a foiled heist. It was a protracted farce. An unexpectedly rapid police response prompted Wojtowicz and his cohort, Salvatore Natuarale, to take eight hostages. The police drew crowds that in turn drew media. Once Wojtowicz revealed that he committed the robbery to finance his homosexual lover's sex change operation, there was no turning back. In Wojtowicz, the press found neither a panic-stricken thug nor an inarticulate loser but a queer and charming personality whose predicament demanded that he play to the watching Flatbush residents, whom the media reduced to a studio audience. Several dynamics were at work,

not the least of them a genuine sympathy for Wojtowicz expressed by the hostages inside and the crowds outside the bank. Cops, crowds, cameras—a ten-minute robbery degenerated into a fourteen-hour standoff that eventually served as the basis for Sydney Lumet's 1975 film *Dog Day Afternoon*.

Of all the reports of what took place during those fourteen hours, Wojtowicz's account is the only one the film's writers failed to obtain. Absent from what the film billed as a true story, Wojtowicz's account assumes the air of a secret, potentially harboring unknown facts. In *The Third Memory*, Pierre Huyghe gives Wojtowicz the directorial reigns, revisiting that August afternoon using Wojtowicz to reenact several scenes from the robbery. The footage from a two camera set-up is projected over two adjacent screens so that the subject of the piece is both Wojtowicz's perspective and Wojtowicz himself. Although this dual projection theoretically challenges a singular, fixed perspective by acknowledging a separation between a viewed and viewing subject, in this case, it also multiplies and magnifies Wojtowicz as the focus of the piece, demanding that his memory produce, as opposed to reveal or discover, a truth.

The title, *The Third Memory*, refers to the event's transformation first into journalistic fact, then into fiction, and finally into memories of the event as they have come to reside alongside the fiction. Huyghe has documented the transition from fact to fiction through the inclusion of related textual and graphic material arranged chronologically, beginning with feature articles that appeared on the front pages of New York newspapers the day after the robbery and ending with an original movie poster. Between them are the *Life* magazine article on which the screenplay was based and title pages of the screenplay's subsequent three drafts. Following the fate of the screenplay from its initial draft by P. F. Kluge, coauthor of the *Life* article, to its final draft, in which sole credit is given to Warner Bros. screenplay writer Frank Pierson, reveals a relatively smooth transition from fact to fiction. The truth/fiction dichotomy, already established through Wojtowicz's presence, here becomes even more conspicuous, judged against a contemporary televisual discourse. Had the event been subjected to the continual news coverage of, say, CNN or the myriad varieties of reality-based entertainment (including docudramas and talk shows), the dichotomy would have dissolved in what has become a hopelessly collapsed binary, as viewers regularly negotiate degrees of truth in fiction and degrees of fiction used to construct and mediate the televised truth.

But this was already true for an earlier generation of television viewing

audiences, who by 1972 had been steeped in dramatic excess whether from soap operas or the nightly news, which throughout the 1960s had become increasingly adept at mediating social unrest. Even then the history of broadcast media had ceased to rest on specific turning points (be they technological or in terms of specific incidents) and had become an accretion of narrativizing conventions capable of accommodating tragedies ranging from domestic dispute to war. In this respect, the Wojtowicz fiasco was on its way to becoming just another story.

After its initial flurry of media attention, Wojtowicz's case was largely ignored until the release of *Dog Day Afternoon* in the summer of 1975. The movie brought new attention to the case, making the film, not the event itself, the means by which Wojtowicz's life became the stuff of "human interest." His saga—his lawsuit against Warner Bros., his former gay spouse's eventual sex change, his divorce from his heterosexual spouse—cropped up in the press as late as 1983.[3] Were it not for *Dog Day Afternoon*, it is safe to say the robbery would have been altogether forgotten, overshadowed by events more symbolic and sensational—Attica, Watergate, and the Patty Hearst ordeal, to name a few. Without the film and its attendant publicity, Wojtowicz would simply have returned to the event exclusively within the space of his memory, where closure of the type associated with the human interest story would have been impossible given that such an event's meaning, if any, is highly questionable.

As a human interest story, told and retold, Wojtowicz's memories as recounted in *The Third Memory* have been stripped of the telltale signs of trauma, leaving Huyghe to inherit the rote mechanics of recollection. Based on the lack of psychological resonance, one would never guess that Wojtowicz attempted suicide before trial, loved both his male and female spouses deeply, mistakenly believed he had terminal cancer before robbing the bank, suffered terrible physical abuse in prison, or felt genuine grief over Natuarale's violent death in the robbery's aftermath. Whereas *Dog Day Afternoon* takes great care to establish the time, temperature, and attitude of Flatbush in August of '72, *The Third Memory* confines Wojtowicz's memories to an austere, placeless set that does not reflect amnesia as much as an inability to connect those memories to a larger context in any meaningful way. The sexual politics of the event go unmentioned, although Wojtowicz was certainly aware of them, given that he had friends who were members of the Gay Activist Alliance. Having consummated a heterosexual marriage in which he had two children, and also having undergone

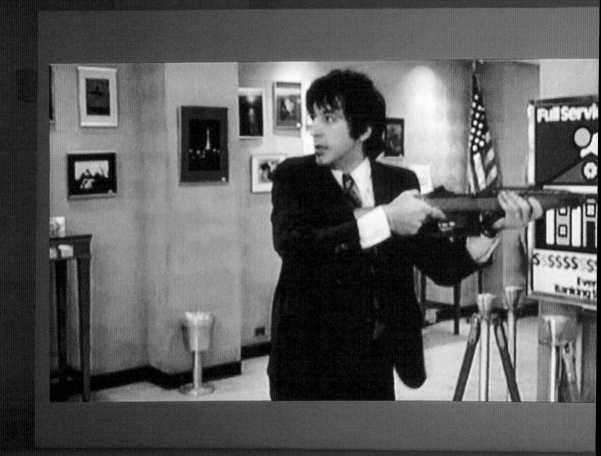

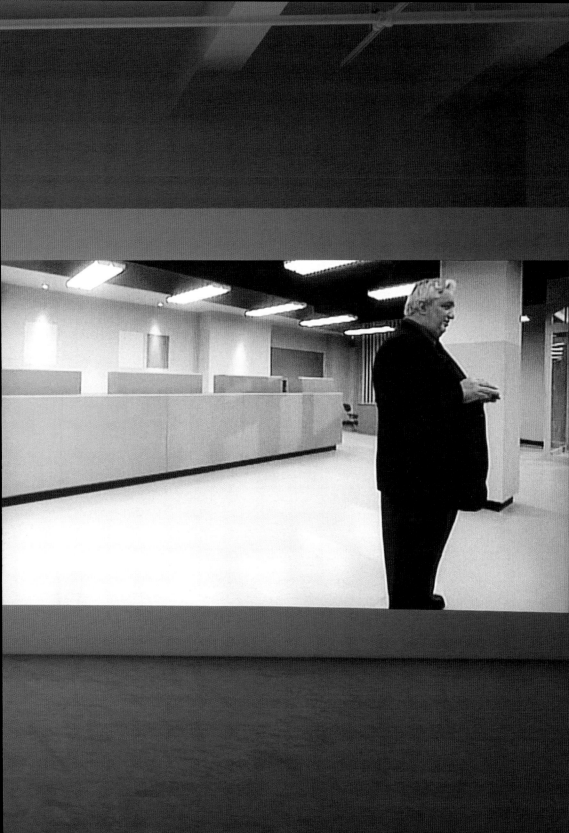

a gay marriage ceremony, Wojtowicz was a genuine swinger, illustrating through ludicrous extremes aspects of an era of so-called sexual liberation.

It is hard to determine if a sense of reflection and criticality are beyond Wojtowicz or if they simply exceed *The Third Memory*'s length. With a running time of ten minutes, it is anything but an exposé. Instead Wojtowicz is given the opportunity to direct and narrate his memories. Fact and fiction are at times humorously blurred, as in Wojtowicz's decision to see *The Godfather* for inspiration the day before the robbery. With a revealing slip of the tongue, he mentions an exchange of gunfire as having taken place in "the real movie," leaving the listener uncertain whether he is referring to real life or *Dog Day Afternoon*. *The Third Memory*'s only moment of direct visual comparison with the film comes when Wojtowicz foils the head teller's plan to use an alarm-triggering key. Wojtowicz's gestures jibe so well with those of Al Pacino that it is impossible to tell whether his memories are being drawn from life or the movie.

Dog Day Afternoon's testimonial accuracy, however, is secondary to a truth quotient based on the event's legitimacy as an antiauthoritarian gesture. The robbery was real insofar as it was quite literally being acted out within an antiauthoritarian discourse that at times openly celebrated criminality. But it was unreal as a credible, let alone legible, utterance of frustration made on behalf of the poverty stricken, the gay community, or some strange combination thereof. In this regard, the film rather astutely understood the event as marking the devolution of 1960s' counterculture into hyperbolic rhetoric, conscious of social unrest as readymade drama. The event was an announcement, well after the fact, of our having become, in Raymond Williams's words, a dramatized society, one that has "never acted so much or watched so many others acting."[4] In the film, the crime and the criminals may have been farcically endearing, but the death of the Natuarale character at the hands of the FBI served to remind viewers that government authority is indeed very real when confronted with Bonnie and Clyde come to life. Yet, the rhetoric dies hard as can be heard in Wojtowicz's voiceover monologue at the beginning of *The Third Memory*.

> *I tell the FBI to go fuck themselves because I'm not going to betray my partner. It's me and him. We don't care about the FBI. We're going to get out of that bank. And we're going to get on that plane. And we're going to do what we have to do without hurting anybody because we're the real Americans, not them.*

This statement refers to Wojtowicz's staunch refusal to make a deal with the FBI, one that would have involved abandoning his cohort, Natuarale. Huyghe alters its meaning by juxtaposing it with the FBI logo as it appears on the copyright notice at the beginning of a rental video. The FBI with whom Wojtowicz refused to negotiate in 1972 is ostensibly the same entity working on Warner Bros.' behalf in 1999, protecting the copyright to a story belonging to Wojtowicz. By this logic, Wojtowicz and the FBI, at the time of the robbery, could just as easily have been arguing over the portrayal and subsequent betrayal of how the event was to be remembered as over the betrayal of Natuarale.

All factual redress takes place under the rubric of a dated and convoluted antiauthoritarian stance in which Wojtowicz accords himself enough agency to convert a highly idiosyncratic act of desperation into a cause of historic proportion. He is (in his own words) "the real American...a millionaire living on welfare." When he and the hostages step out of the bank, they "will be making history." Given the excess of such claims and Wojtowicz's sense of entitlement, expressed through his monetary gripes with Warner Bros., his reenactment is tainted with a narrative of pedestrian righteousness: he's the little man who has been cheated by business execs. This recasts him as a victim. Never once does he mention his initial motive for robbing the bank, which was to finance his homosexual lover's sex change. That sentiment falls by the wayside, and in a classic case of wish fulfillment, as if subconsciously guilty about Natuarale's death, Wojtowicz flatly states that the reason for robbing the bank was to save Natuarale's life. Far less convoluted is Wojtowicz's conjuring the specter of Nixonian paranoia, which would have been in full effect given the event's proximity to Watergate.

The event was no doubt a spectacle, capable, as Wojtowicz says, of bumping live coverage of Nixon from the air.[5] In all likelihood, Nixon, as Wojtowicz suggests, was in a rage after hearing of the robbery. Given that assassination was an option exercised by the FBI's counter-intelligence (Cointel) program, an order to kill the "gay bank robbers" issued from someone high in Nixon's administration, by the likes of, say, G. Gordon Liddy, would not have been out of the question. But there is a substantial difference between speculating about whether such orders were issued and believing they actually were being carried out, as Wojtowicz claims. According to the account in the New York Times, Wojtowicz was apprehended after Natuarale was shot and

killed in a hostage rescue operation set up by the FBI. These events took place in the getaway van on a Kennedy airport runway with the hostages present as witnesses. The *Times* even went so far as to include a diagram of the action. No shot other than that used to kill Natuarale was reported being fired. According to Wojtowicz, however, he and Natuarale were forcibly disarmed after a shootout. Two FBI agents then held down Natuarale while a third agent shot him at point-blank range. The same fate would have befallen Wojtowicz had it not been for the Port Authority police, who took him into their custody.

Is Wojtowicz telling the truth? Perhaps he is exaggerating, albeit greatly, so as to convey the tenor of the times. This may be the only meaning he can ascribe to the event. A more pertinent question is, should or does one need to look to Wojtowicz for the truth? Based on Frederic Jameson's allegorical reading of *Dog Day Afternoon*, the answer is no. For him, the film captures structural shifts in class relations that "cannot in the very nature of things be rendered directly."[6] A reading along these lines, however, severs the film from its source. Through the figure of Wojtowicz, *The Third Memory*, for better and or worse, reinstates the film's anecdotal source material. The result is a regression in narrative paradigms, from a performance by Al Pacino typifying the golden age of method acting, to a performance by Wojtowicz that more closely resembles something along the order of *COPS*. Whereas Pacino's bravura acting is the film's immediate and non-allegorical truth, television believes it has access to a world that is true by virtue of being unscripted. This is television's greatest fiction, one that exploits a past in which television genres were still neatly divided into news and entertainment. Expecting to produce a truth that was buried three decades ago, *The Third Memory* is a retroactive ideal of television, obviously one that never existed. And for that, Wojtowicz ought to be thanked for the memories.

Notes

1. Guy Debord, "In Girum, Imus Nocte et Consumimur Igni," in *Oeuvres cinematographiques completes 1952–1978* (Paris: Editions Champ Libre, 1978), pp. 207–208. Cited in Thomas Y. Levin, "Dismantling the Spectacle: The Cinema of Guy Debord," in Elisabeth Sussman, ed., *On the Passage of a Few People through a Rather Brief Moment in Time: The Situationist International 1957–1972* (Cambridge: MIT Press, 1991), p. 73.

2. Frederic Jameson, "Class and Allegory in Contemporary Mass Culture: *Dog Day Afternoon* as a Political Film" (1977), in Michael Hardt and Kathi Weeks, eds., *The Jameson Reader* (Malden, Massachusetts: Blackwell, 2000), p. 293.

3. Press coverage included accounts of his lover's successful sex change, going from Ernie Aron to Elizabeth Eden (a combination of Elizabeth Taylor and the Garden of Eden), and of three separate law suits against Warner Bros. filed by Wojtowicz, his wife, Carmen, and Eden shortly after the movie's release. Warner Bros. eventually awarded Wojtowicz $100,000. Subsequent news briefs covered these ongoing court cases and settlements, in particular the New York State Victims Compensation Fund's impoundment of the $100,000. Also judged newsworthy were Eden's engagement to an air conditioning repairman; Wojtowicz's eventual release from prison after serving almost seven years; Wojtowicz and Carmen's marital problems; and their eventual divorce after Carmen's $150 weekly stipend, drawn from the victims fund, ran out.

4. Raymond Williams, "Drama in a Dramatized Society," in Alan O'Connor, ed., *Raymond Williams on Television: Selected Writings* (New York: Routledge, 1989), p. 3.

5. That same evening, Nixon announced his bid for reelection in a speech delivered in Miami.

6. Frederic Jameson, "Class and Allegory in Contemporary Mass Culture: *Dog Day Afternoon* as a Political Film" (1977), in Michael Hardt and Kathi Weeks, eds., *The Jameson Reader*, p. 305.

NEIL JORDAN

NOT
I

2000

WHAT WE NOW SEE AS NEIL JORDAN'S INSTALLA-
TION *NOT I* HAD ITS ORIGINS IN DUBLIN'S
GATE THEATRE'S 1991 STAGING OF ALL NINETEEN
OF SAMUEL BECKETT'S STAGE PLAYS. COMING
TWO YEARS AFTER THE PLAYWRIGHT'S DEATH IN
PARIS, THIS BECKETT FESTIVAL, WITH MINOR
VARIATIONS AND ADDITIONS, WAS SEEN IN NEW
YORK AND IN AUSTRALIA LATER IN THE 1990S,
FINALLY RETURNING TO LONDON'S BARBICAN
CENTRE IN 1999. AT THAT TIME, THE GATE
THEATRE'S ARTISTIC DIRECTOR, MICHAEL
COLGAN, INITIATED WHAT WOULD BECOME *BECKETT
ON FILM,* WHICH WOULD PAIR ESTABLISHED AND
EMERGING FILMMAKERS (THE LATTER MAINLY
IRISH) WITH THE NINETEEN BECKETT PLAYS,
TO PRODUCE CINEMATIC ADAPTATIONS LIKELY
TO REACH A WIDER, MORE VARIED AUDIENCE
THAN THE STAGE PRODUCTIONS HAD.[1]

With principal funding from RTÉ, the Irish radio and television network, the Irish Film Board, and Britain's Channel 4, *Beckett on Film* could not have progressed without the endorsement of Beckett's estate, which has a well-documented record of blocking, or attempting to block, productions of the dramatist's work that would violate the typically very exacting stage directions he'd provided. In 1985, to cite a well-known instance, Beckett issued a formal complaint to the American Repertory Theater in Cambridge, when Mabou Mines director JoAnne Akalaitis altered the setting for her production of *Endgame*, from a neutral interior to an abandoned subway station, and reports still occasionally appear in the press of producers thwarted in their efforts to produce all-female versions of *Waiting for Godot*. But such literal transposi-

tions, in the context of a live stage performance, are dwarfed in advance by the range of meaningful alterations that can't be prevented from attaching themselves to the texts once the transition from stage to screen has begun.

As Colgan later told Alan Riding of the *New York Times*, the estate endorsed the *Beckett on Film* project, with certain provisos: " 'We worked out a bible to give the directors,' Mr. Colgan recalled. 'No cuts, no gender-bending, and if Beckett says "beach," there should be a beach. We didn't want adaptations or "inspired by" stuff. We needed directors with a sense of the importance of the text. That's why we sought out writer-directors. We let them choose their own casts, but this project is not actor-led, it is director-led.' "[2]

Riding continued: "Posing a greater challenge to directors than casting, though, is how to translate Beckett to the screen without changing a single word or text. Camera movements, editing cuts, and above all close-ups naturally create a different visual narrative from that seen in a theatre. But because film is a more literal medium than theatre, where a single light on a darkened stage is enough to create a mood, some directors elaborated on Beckett's proposed staging."[3]

As it happens, Beckett had himself already colluded in altering his own stage directions for *Not I*, for its first television adaptation, a 1977 BBC production with Billie Whitelaw (the playwright's preferred female interpreter) performing the piece at the Royal Court Theatre, where she had premiered it in 1972. Beckett had made the same alteration the previous year for a French stage production starring Madeleine Renaud. Here is the excerpt from the Beckett's original stage directions:

> *Stage in darkness but for MOUTH, upstage audience right, about 8'*
> *above stage level, faintly lit from close-up and below, rest of face in*
> *shadow. Invisible microphone.*
>
> *AUDITOR, downstage audience left, tall, standing figure, sex*
> *undeterminable, enveloped from head to foot in loose black djellaba,*
> *with hood, fully faintly lit, standing on invisible podium about 4' high,*
> *shown by attitude alone to be facing diagonally across stage intent on*
> *MOUTH, dead still throughout but for four brief movements where*
> *indicated. See Note.*

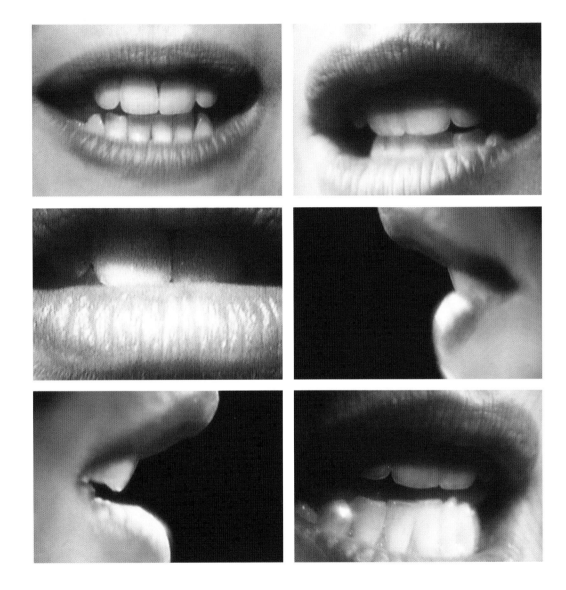

As house lights down MOUTH's voice unintelligible behind curtain.
House lights out. Voice continues unintelligible behind curtain, 10
seconds. With rise of curtain ad-libbing from text as required leading
when curtain fully up and attention sufficient unto:[.]"[4]

Thus in the play's original form the stage would reveal the spotlighted,
disembodied, speaking Mouth, suspended eight feet above stage level, and
the silent Auditor, who gestures slightly at four moments during the Mouth's
monologue but is otherwise sedentary. Attempts at producing a film version
of this tableau, however, drastically altered the emotional and dramatic values
of the Mouth, no matter what attempts at re-blocking it for the confines of the
screen were attempted, so Beckett opted to leave out entirely the figure of the
Auditor, noting about the character, "He is very difficult to stage (light-position)
and may well be of more harm than good. For me the play needs him but I can
do without him. I have never seen him function effectively."[5] Hence, on film,
Not I becomes an extreme close-up of the Mouth.

Written in English in 1972, *Not I* is an agonized aria, recounting, as both
torrent and fragment, a full lifetime's worth of incomprehensible rage. Speaking
as much to herself as to the silent Auditor, as to us, "she" is no more than her
mouth, lacking even the awareness essential to conceive of herself in the first-
person, and one of the monologue's internal tensions is in the struggle for
an "I" or a "my" to override the "she" and the "her" into which the Mouth
defaults. Beckett's ending stage directions for *Not I* describes the Auditor's
periodic gestures in response to Mouth's words, noting, "It lessens with each
recurrence till scarcely perceptible at third. There is just enough pause to
contain it as Mouth recovers from vehement refusal to relinquish third person."[6]

Extracted by the viewer into something resembling an identifiable
character, it's as though Mouth—"...out...into this world...this world...tiny
little thing...before its time..."—had spent her entire lifetime in a sort of coma
("... found herself...and if not exactly...insentient...insentient...for she could
still hear the buzzing...so-called...in the ears..."), and suddenly is shocked into,
if not wakefulness, at least its waiting room, uncertain even of her age: "...how
she had lived...lived on and on...guilty or not...on and on...to be sixty...something
she...what?...seventy?...good God!...on and on to be seventy...something she
didn't know herself...wouldn't know if she heard...then forgiven...God is
love...tender mercies...."

Beckett's theater remains one of radical gesture, which *Not I* confirms in its confinement of dramatic action to the literal source of speech production. *Not I*'s enactment of gender's formation in language—indeed, of feminine subjectivity emerging under patriarchy—is nothing if not intensified in the film version in which the close-up of the mouth attains a corporeality, a fleshiness, it lacks onstage, becoming as much a speech source as a living organism, a human orifice, invariably resembling a vagina, particularly when filmed frontally in a single shot, as the Billie Whitelaw version is.[7]

The version of *Not I* produced by Neil Jordan for *Beckett on Film* is a heavily edited monologue, shot from six different close-up angles: left and right profile, left and right three-quarter profile, and frontally from two slightly different distances. The actress Julianne Moore, whom Jordan had just directed in his adaptation of Graham Greene's *The End of the Affair*, performed the thirteen-minute monologue straight through a number of times, with the final version drawing from all six angles. One could debate the extent to which Jordan's conception "violates" Beckett's vision—the rhythmic editing cut in sympathy to the emphases of the text (especially as cued by Mouth's periodic laughs and screams), rather than the sustained, single-point perspective of the stage—but the actual appearance of Julianne Moore, entering and sitting in a head-stabilizing chair in advance of speaking, is certainly at odds with the lengths to which Beckett endeavored to conceal the body and the face behind the Mouth.

Born in Sligo, Ireland, in 1950, Jordan came to prominence originally as a fiction writer, and his highly varied work as a screenwriter and director (including an Academy Award for *The Crying Game*'s script in 1992) remains faithful to that aspect of his creative instincts; indeed, critic David Denby credits Jordan with having "perhaps the most poetically eloquent temperament in the English-speaking language," among film directors currently working.[8] In reconfiguring *Not I* as an installation for the Irish Museum of Modern Art in February 2001, Jordan dismantled his own version of the *Beckett on Film* piece, this time removing all the edits and restoring Julianne Moore's performances to uninterrupted, single-take monologues, captured according to the six different camera angles. Reflecting on the installation (the first he'd ever produced), Jordan noted, "I had a series of records of the same event, the same performance, from different angles, each with their own integrity....If I could pull them all into sync and present each angle, simultaneously, to the viewer,

the multiplicity with which cinema presents the world would be accessible to the viewer in a unique manner. Artists have long engaged themselves in a dialogue with the grammar and aesthetics of cinema, but the dialogue has rarely gone the other way. And Beckett's luminous piece could be presented in a context that was neither cinema nor theatre, but something quite different."[9]

The resulting six-monitor installation, beyond offering a viewer a chance to compare these versions with the edited "final" one in *Beckett on Film*, acts as an archive or repository for Moore's "live" performance to gain a second life, as the viewer stands encircled in the darkness and becomes, first and last, the embodied conscience of the banished Auditor.

NOT
I

Notes

1. *Beckett on Film* had festival and public television screenings in 2000 and 2001 prior to its release as a four-disk DVD boxed set. Among other directors contributing to the project are Atom Egoyan (*Krapp's Last Tape*), Patricia Rozema (*Happy Days*), David Mamet (*Catastrophe*), Karel Reisz (*Act Without Words I*), Anthony Minghella (*Play*), and Damien Hirst (*Breath*).

2. Alan Riding, "Finding New Audiences for Alienation," *New York Times*, June 11, 2002 (reproduced on the *Beckett on Film* web site, www.beckettonfilm.com/colgan_interview.html).

3. Ibid.

4. Samuel Beckett, *Not I* (London: Faber & Faber, 1973).

5. Quoted on Ch. 4 (U.K.) web site, www.channel4.com/learning/main/netnotes/sectionid100664758.htm.

6. Beckett, *Not I*.

7. Some of these issues, including a discussion of how such varied commentators as Julia Kristeva and Peter Gidal have analyzed *Not I*, are explored in *Samuel Beckett: Teleplays* (Vancouver: Vancouver Art Gallery, 1988), the catalogue for an exhibition of Beckett works adapted for television, curated by the artist Stan Douglas.

8. Quoted in *Leonard Maltin's Movie Encyclopedia*, ed. Spencer Green and Luke Sader (New York: Dutton, 1994), p. 448.

9. Neil Jordan, quoted in press materials provided by the Irish Museum of Modern Art (2003).

DONALD MOFFETT

WHAT BARBARA JORDAN WORE

2002

DAWN'S EARLY LIGHT
Gregg Bordowitz

...IN ORDER TO FORM A MORE PERFECT UNION...
—The Constitution of the United States of America

Donald Moffett's recent installations—consisting of video material projected onto monochromatic paintings—address constitutional questions of form and matter strictly obeying the legislative features of light. How does light legislate? Light is a discipline upon the eyes. Sight is impossible without it, and apprehension is slave to its values. Too dim, the eye strains. Too bright, the lids shut against the pain. Clarity of vision entails an accommodation. We need a moderate amount of light.

 "It is reason, not passion, which must guide our deliberations, guide our debate, and guide our discussion." Congressperson Barbara Jordon, representative from Texas, said that, in her opening statement to the House Judiciary Committee proceedings on the impeachment of Richard Nixon, on July 25, 1974. The text of Jordan's statement serves as the audio track for Moffett's installation titled *What Barbara Jordan Wore*. Three gold hued paintings act as the screen for three digital projections, each shone onto one of the painted surfaces and sized to match the proportions of the canvas. The center panel depicts Barbara Jordan delivering her opening statement. Another panel shows an image of the judiciary committee, and the third panel displays an image of the people observing the proceedings.

 Jordan was the inveterate servant of those she represented. The enlightened authority of the constitution vested her speech with authority. With equanimity and grace, the congressional representative forcefully made her case that the wrongs of the executive met the criteria for impeachment. The legislature sat in judgment, and the people bore witness. This much we can discern with our eyes and ears. The images projected onto the panels give enough detail, enabling us to distinguish between the actors. The sound track of Jordon's voice assigns her the leading role in the drama. Yet, the sound is not in synch with the image. And the worked metallic surfaces of the paintings resist the specific details of the projected physiognomies. These ambiguities in the work are the substance of Moffett's project. The central concern of *What Barbara Jordan Wore* is the abstraction of history itself.

Nixon's impeachment proceedings are anchored to a specific time and place in history. Moffett transforms them into a meditation on the impersonal nature of power.

The obscuring of facial detail in *What Barbara Jordan Wore,* particularly among the faces of the crowd, is a remarkable aspect of the installation. What constitutes a face? According to Emmanuel Levinas, the unique details of a face that make an other recognizable to us are *not* the characteristics that hail us into a relation with the other. The face itself, any face—two eyes, a nose, and a mouth—is *the* sign that calls us to our responsibilities.

**WHAT
BARBARA
JORDAN
WORE**

Ordinarily one is a "character": a professor at the Sorbonne, a Supreme Court justice, son of so-and-so, everything that is one's passport, the manner of dressing, or presenting oneself. And all signification in the usual sense of the term is relative to such a context: the meaning of something is in its relation to another thing. Here, to the contrary, the face is meaning all by itself. You are you. In this sense one can say that the face is not "seen." It is what cannot become a content, which your thought would embrace; it is uncontainable, it leads you beyond.[1]

One of the most prominent features identifying Jordon is the darkness of her skin. She addressed the significance of this herself in the recorded statement when she noted that George Washington and Alexander Hamilton neglected to include her, and people like her, in the preamble of the constitution, famously beginning with the words "We the people..."

Values don't follow from facts. This assertion is as true of racism as of aesthetic judgment. The value one assigns to a person's skin color does not derive from the factual nature of pigmentation. While it is a fact that people have differently colored skin, our feelings about a person, and the judgments we make of their appearance, are products of our own minds. Similarly, the personal and social meanings we assign to the colors of a painting are creatures of context. Color is relational. It's defined by the qualities of things around it. The palette of Moffett's monochrome paintings is dominated by gold, but the underpainting bleeds through the glittering surfaces, producing a varicolored field. Many hues are hard to name. The subtle nuances are significant. The ambiguity of color here poses an ethical challenge.

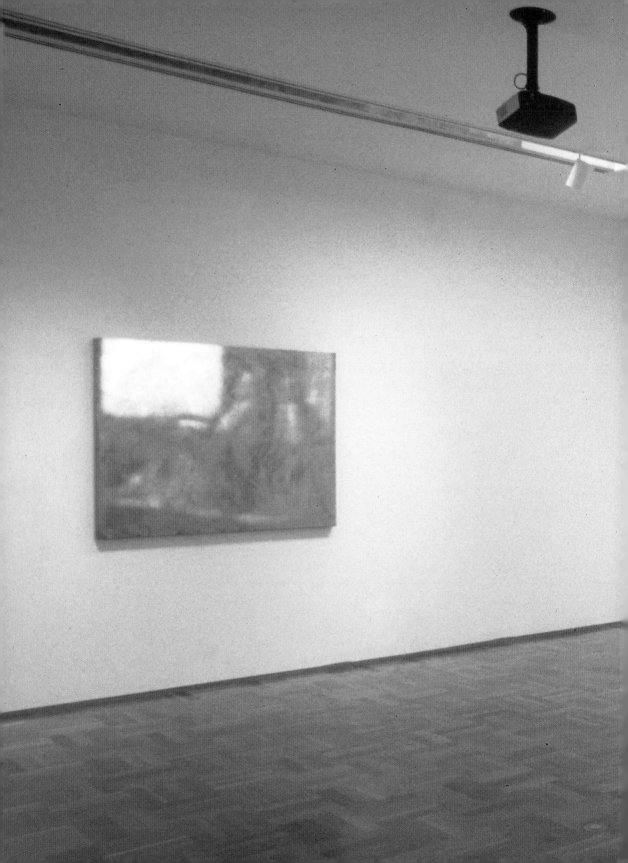

What constitutes color? The color of a thing is not an inherent property of the thing. When light hits an object, it bounces off the surface reflecting into the eyes. The eyes translate the qualities of the reflected light, determined by the molecular constitution of the reflecting object, into our perception. In other words, we produce the colors of things through observation.

Light legislates vision, but it does not rule the sentiments. What constitutes the sentiments? In a recent body of work titled *Extravagant Vein,* Moffett returns to the formula of projections onto nearly monochromatic paintings. The projected material consists of edited and looped video images taken within the Rambles of New York's Central Park. The imagery recalls lyrical landscape paintings by artists like Caspar David Friedrich, Camille Corot, or, on one occasion, Claude Monet. The Rambles is a beautiful wooded area, a prime location for birdwatching, where sometimes a mere number of feet separate families strolling down paths from men looking to meet other men under cover of foliage.

Most of the video loops record some action in the landscape—by a figure or a dog or ducks—as fleeting instances in the otherwise desolate pastoral scenes casually animated by the variances of wind and light. The diptych titled *Gold/Tupelo Plains* (2003) depicts a path surrounded by trees. One panel shows the left side, the other the right. In the left panel two young men, small and to the right side of the canvas, sit on a park bench with one turning his face up to the light every seventeen seconds or so. A little drama unfolds in the right panel. A figure enters the frame in the deep background, searching. Then, another figure enters. The two may or may not regard each other. It's hard to tell. They exit the scene in different directions. Here, erotic encounter is the theme. The drama of sexual possibility unfolds deep in the state of urban nature. What occurs remains a mystery to the observer, as the video loop captures a chance encounter of two men who may or may not choose to recognize each other with their gazes. The playlet offers this meditation on ethics: What constitutes love?

> *The idea of love that would be a confusion between two beings is a false romantic idea. The pathos of the erotic relationship is the fact of being two, and that the other is absolutely other.*[2]

The landscapes of *Extravagant Vein* revisit a core premise of nineteenth-century romanticism—the pathetic fallacy—that nature has feelings of its own.

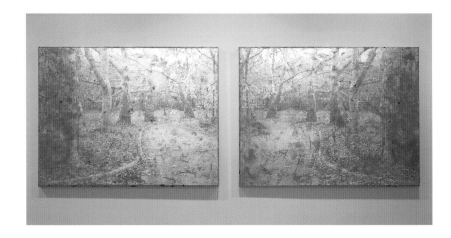

WHAT BARBARA JORDAN WORE

Moffett's pictures don't reject the notion that nature has feelings. His embrace of lyricism confirms that assertion. And he imagines that people are part of nature, albeit a nature captured and tamed, made inhabitable by culture—the public park. The projection/paintings in this body of work envision an ideal public common, where nature is approached by urban residents of New York City retreating to the plant life of the park as a respite from the concrete. Nature here is defined by public use but not fully contained by it. The various users negotiate the park's purpose, and each user contributes to a public imagination of civic potential. The park remains indifferent to its users and manicurists; it continues on after the players quit the field.

Ultimately, we must draw our conclusions by considering the constitution of the work itself. *What Barbara Jordon Wore* and *Extravagant Vein* are gallery installations in which paintings are lit by digital video projectors. Moffett's singular contribution to the overabundance of projections in galleries lies in his *literal* transposition of projected light onto the conditions of painting. We've all grown accustomed to walking into darkened galleries, micro-cinemas really, where we watch art videos exhibited as if they were short movies. The dominant acceptance of the cinematic orientation to the wall-as-screen is a default mode easily integrated into the space of the art gallery, because painting has a longstanding affair with walls. Recently, many projection artists have attempted to free themselves from the painter's subjugation to walls by

using freestanding screens. This shift to a seemingly sculptural, or architectural, solution fails in most cases to escape the formal conditions of painting. Nine times out of ten, we're standing in galleries watching moving paintings.

It's difficult to dismiss such works as failures. Many artists obviously want their work to be considered on a continuum with painting. Is there an inherent opposition between the brushstroke and the pixel? Well, there used to be. Artists in revolt against the confining conditions of painting, and all the fleshy things painting implied, were the first to embrace video—though the history of this revolt is as old as photography. Today, the war between hand-made reproduction and mechanical reproduction seems moot. Many artists work comfortably between the analog and the digital. There is no way at present to produce credible work that does not proceed in this way.

Digital technology allows endless reproducibility with no degradation in quality. It forces the abandonment of an ideal singular original. Theorists of the digital exaggerated the importance of this technological advance, making hasty pronouncements about the end of the analog. Artists know that the methods of creative production still rely heavily on analog procedures—drawing, writing, perception, and sensation. You can use digital technology to achieve your ends, but you must still resort to the bodily ways of work and all the subjective, idiosyncratic means necessary to art's making and exhibition. Whatever means you use, you still have analog people looking at your work.[3]

Donald Moffett's installations contain all the terms of previous contentions— the hand and the machine, the analog and the digital, the paint and the pixel, the figurative and the abstract. By combining painting and video, they surpass the limits of both mediums. They embody a genuinely novel set of circumstances. Moffett is writing a new constitution of light for a technologically advanced democracy in potential. The luminosity is not twilight. It's sunrise.

Notes

1. Emmanuel Levinas, *Ethics and Infinity, Conversations with Philippe Nemo*, trans. Richard A. Cohen (Pittsburgh: Duquesne University Press, 1985), pp. 86–87.

2. Levinas, p. 66.

3. For a much more elegant and rigorous inquiry into the relation between the digital and the analog, consult the chapter "On the Superiority of the Analog" in Brian Massumi, *Parables for the Virtual: Movement, Affect, Sensation* (Durham and London: Duke University Press, 2002), pp. 133–143.

LORNA SIMPSON

31

CANDID CAMERA

Aruna D'Souza

LORNA SIMPSON'S VIDEO INSTALLATION *31*, FIRST PRESENTED AT DOCUMENTA XI (2002), CONSISTS OF THIRTY-ONE VIDEO MONITORS ARRANGED IN A GRID ON A LARGE WALL. EACH MONITOR SHOWS THE MOSTLY BANAL ACTIVITIES OF A YOUNG WOMAN TRACKED OVER THE COURSE OF A SINGLE DAY.

On various screens, we see her waking up in the morning, going into the bathroom to prepare herself for the day, leaving her apartment and crossing the courtyard of her building to reach the street, walking down the street, arriving at work, going shopping at Kmart, going to bars and restaurants, attending gallery openings, meeting friends, returning home at night, sleeping, etc. Occasionally, her activities seem less ordinary: at one point, she is dressed in scrubs, standing outside a hospital's operating room; at other points we are aware that the bed she wakes up in isn't her own. With the screens arranged seven across, and with each screen displaying a single day's goings-on, we are meant to read the arrangement as that of a calendar: the actions of the woman thus are understood as spread out across the thirty-one days of the month. But at the same time, the array of so many monitors on the wall reads as something like a bank of security cameras, allowing us relatively unrestricted visual access to the spaces of this young woman's life. It is the intertwining of these two ideas—the banality of everyday activities seen through the visual mode of surveillance—that renders Simpson's work so provocative.

Since the early 1980s, Simpson has investigated the underlying ideology of the photographic medium, especially its role in constructing images of gender and race. In works that took as their subject the black female body placed against an unarticulated background, most often turned away from the camera, and juxtaposed with text, Simpson both cited and denied the ways in which the photographic gaze constructs the female body as an object of vision, and thus of desire. At the same time, however, these anonymous, archetypal, and recalcitrant figures reminded us of the ways in which photography as a medium has been deployed from its very beginnings as a tool of classificatory science, of forensics and ethnography, of criminology and racial typologies.

And yet, if Simpson's work "call[ed] our attention to photography as an apparatus of discipline,"[1] she thwarted that function, too: far from providing any purportedly neutral, informational view of the subject of its gaze, the camera was frustrated in its effort to reveal, both because of the models' resistant poses and because of the layering of visual stereotypes and textual additions.

31 follows this subversive logic, deploying certain tropes of the medium only to turn them against themselves, thus removing the black female body from its usual position as the object of erotic and forensic gazes. This time, however, the medium is filmic rather than photographic. Simpson seems acutely aware of the fact that classic cinema normally invites the viewer to align his gaze with the camera's framed view.[2] As such, the moviegoer becomes a kind of voyeur, given access to a visual world that is unconscious of his presence, that makes no acknowledgement of his view onto a scene; he is thus allowed a kind of uncompromised vision that fulfills a range of scopic desires. Moreover, this invitation to erotic vision constructed in classic cinematic experience was one that positioned women as objects, never or rarely as subjects, of the look. Film, then, would provide Simpson an important opportunity to stage new strategies of subversion, in order to render unavailable the female body—especially the black female body—to the possessive, desiring gaze.

31, at first, strikes us as unproblematically voyeuristic: we are privy to an unnamed woman's most private actions, which she executes without any awareness of our presence. But there is something curious about the way in which Simpson frames this seemingly voyeuristic access. The camera, in most instances, is fixed, not following the woman around a space but trained, immobile, on the view in question. The woman moves in and out of the shot at will, with some action taking place, necessarily, off screen. The technique is one used most effectively in Chantal Akerman's film *Jeanne Dielman, 23 Quai du Commerce, 1080 Bruxelles* (1975), whose cinematographer, Babette Mangolte, was one of Simpson's instructors during her M.F.A. training at the University of California, San Diego, in the early 1980s. In that film, which also focuses its attention on the banality of the everyday activities of a particular woman, the filmmaker refuses to set up privileged points of view on the action using the normal methods of close-ups, cut-ins, and reverse shots, creating a "rupture in cinematic narrative's techniques of spectator suture and identifica-

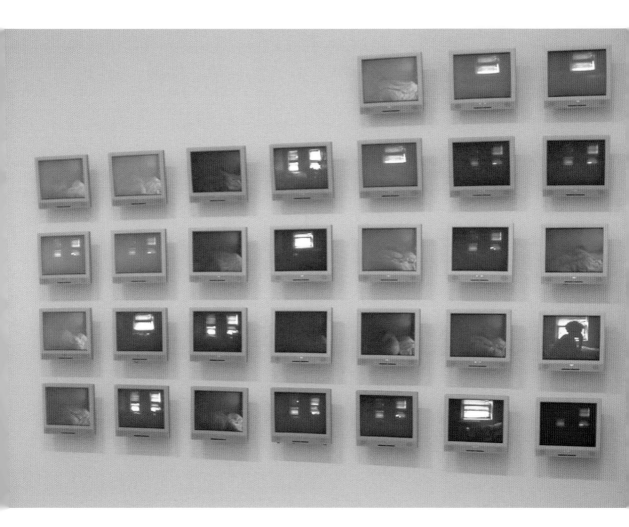

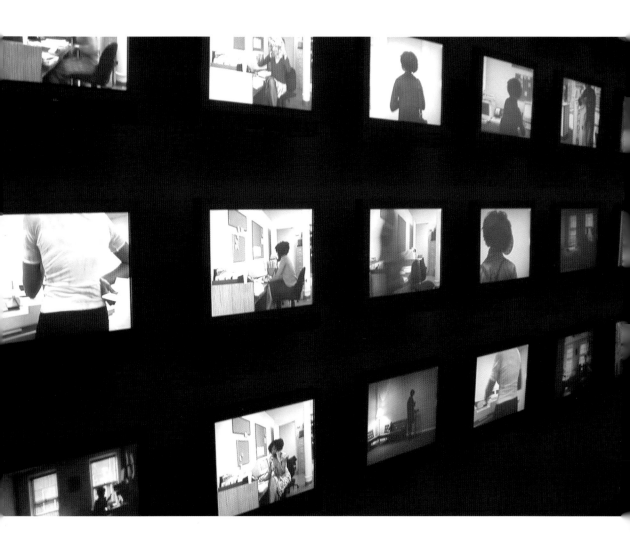

tion."[3] In an almost anthropological way, Akerman's camera simply proposes to capture everything that happens within a given space, with no one action or event taking narrative priority over any other, so that when, in the only real climatic moment of the film, a murder takes place, its shocking brutality is equated formally with earlier scenes of household activity. Akerman's framing device, then, serves two purposes: it refuses to acknowledge conventions of cinematic narrative, and at the same time it refuses the conventional aligning of the viewer's (desiring) gaze with the camera's view.

31 has its own moments of climatic fissure—scenes in which the woman goes to a funeral home, for example, for a purpose unexplained by her prior actions—that seem to rip apart the structured regularity that the repetition of daily activities on other screens seems to suggest. But more significant is the way in which Simpson takes advantage of the ruptures in scopophilic fantasy that Akerman's formal method enacts. For, as in Akerman's *Jeanne Dielman*, the fixed camera of *31* refuses the libidinal logic of classic, voyeuristic cinema: it does not search out its object of desire; it is predicated on the *impossibility* of following the object out of the visual frame. Further, by replacing a single screen (as used by Akerman) with multiple screens, Simpson replaces the voyeur's gaze with the surveillant gaze, such that the fixed frame can be read as a kind of mechanized security camera, which picks up activities indiscriminately and surreptitiously.

In the voyeuristic impulse of classic film, the viewer is allowed to remain passive in front of the cinematic spectacle, invited (or coerced) into looking in a particular way and experiencing the story in a highly structured form. *31* obviously upsets this scenario, for there is no one place to look: instead, viewers must choose which screen on which to focus attention and construct a logic of viewing based on their own criteria. Here, the lack of narrative continuity across the thirty-one screens compels viewers to acknowledge their own desire or curiosity as motivating their mobile glances across the monitors. One might choose to compare, for example, what the woman does first thing in the morning by successively scanning all thirty-one screens, or alternatively one might decide to track her movements in a single day by following the events on a single monitor. The viewer is thus made an active participant in the cinematic encounter. One's view of the work is thus necessarily fragmented and partial; there is no way to capture the narrative logic of the work in a single, coherent linearity. In part, this is because of the seriality of the mode of display—a

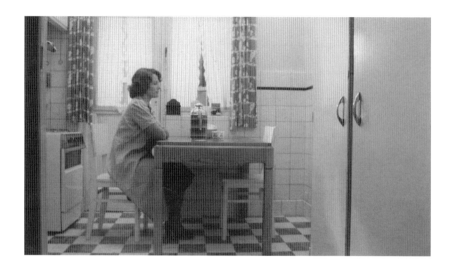

Chantal Akerman
Jeanne Dielman,
23 Quai du Commerce,
1080 Bruxelles, 1975

repetition of screens on the wall—and in part it is due to the seriality of the subject: an accounting of events determined not by a dramatic logic but by the arbitrary logic of a calendar month.

As much as Simpson poses the surveillant gaze as counter to the voyeuristic gaze, she is as critical of the former as of the latter. If the disciplinary mode of the surveillance camera structures our view of the regularity of this woman's private life and work life, Simpson also, through subtle formal shifts, inserts moments into the various films that interrupt such regularity, "undermining the strictly controlled parameters of social space."[4] In one telling sequence that takes place on the thirteenth day, the woman goes to a nightclub onto whose walls are projected a pulsating, psychedelic pattern; here, unusually, the camera offers us a view that is both mobile and searching, seemingly jostled by the movements of the dancing bodies that crowd the scene and providing us with fully frontal, cinematic views of the woman's face, suffused with pleasure. Instead of the neutral, forensic view that we have been offered in the previous scenes, we are instead offered access into the crowd that is immersive, disorienting, and sensual. In moments like these Simpson interrupts the clinical nature of her earlier mode of address: it is as if she is pointing out the way in which our lives exceed, in those rare moments of pure sociability, the discipline that otherwise structures our everyday existence.

Notes

1. Kellie Jones, "(Un)Seen and Overheard: Pictures by Lorna Simpson," in Thelma Golden, Chrissie Iles, and Kellie Jones, *Lorna Simpson* (London and New York: Phaidon Press, 2002), p. 34.

2. As much feminist film theory reminds us, there are gendered implications in the filmic encounter, and the viewer is often constructed in classic cinema as occupying a masculine subject position. See, for example, Laura Mulvey, "Visual Pleasure and Narrative Cinema," in *Visual and Other Pleasures* (Bloomington and Indianapolis: Indiana University Press, 1989), pp. 14–26.

3. Ivone Margulies, *Nothing Happens: Chantal Akerman's Hyperrealist Everyday* (Durham and London: Duke University Press, 1996), p. 6.

4. Chrissie Iles, "Images between Images: Lorna Simpson's Post-narrative Cinema," in Thelma Golden, Chrissie Iles, and Kellie Jones, *Lorna Simpson*, p. 115.

CHECKLIST OF THE EXHIBITION

Kutlug Ataman

Turkish, b. 1961

The 4 Seasons of Veronica Read, 2002

Four DVDs, continuous loop
Four-screen video installation with
variable dimensions

Courtesy of the artist and Lehmann
Maupin Gallery, New York

Matthew Barney

American, b. 1967

Drawing Restraint 7, 1993

Video monitors, laser disc players,
silent color laser discs, steel, plastic,
and florescent lighting fixtures
Running time: 9 minutes and
11 seconds

Whitney Museum of American Art,
New York; Purchase, with funds from the
painting and sculpture committee 93.33

Tacita Dean

British, b. 1965

Fernsehturm, 2001

16mm color anamorphic film,
optical sound
Running time: 44 minutes

Courtesy of the artist, Marian Goodman
Gallery, New York, and Frith Street
Gallery, London

Andrea Fraser

American, b. 1965

Little Frank and His Carp, 2001

DVD
Running time: 6 minutes

Courtesy of the artist and Friedrich
Petzel Gallery, New York

Pierre Huyghe

French, b. 1962

The Third Memory, 2000

Two-channel video projection, single
channel monitor video, and posters
Dimensions variable
Running time: 9 minutes and
46 seconds

San Francisco Museum of Modern Art;
Purchased through a gift of The Art
Supporting Foundation to the San
Francisco Museum of Modern Art and
the Accessions Committee Fund: gift of
Doris and Don Fisher, Helen and Charles
Schwab, Danielle and Brooks Walker, Jr.,
and Robin Wright

Neil Jordan

Irish, b. 1950

Not I, 2000

Six-monitor DVD installation from film
directed by Neil Jordan, produced by
Blue Angel Films
Variable dimensions
Running time: 14 minutes

Collection Irish Museum of Modern Art,
donated by the artist, 2000

Donald Moffett

American, b. 1955

What Barbara Jordan Wore, 2002

Installation of oil and enamel on linen
with video projection
Three parts, each: 45 x 60 in.
(114.3 x 153 cm)
Running time: 13 minutes and
30 seconds

Collection Museum of Contemporary Art,
Chicago, restricted gift of Nancy A. Lauter
and Alfred L. McDougal, Judith Neisser,
Barbara and Thomas Ruben, Faye and
Victor Morgenstern Family Foundation,
and Ruth Horwich

Lorna Simpson

American, b. 1960

31, 2002

Thirty-one individual monitors of
thirty-one video sequences
Dimensions variable
Running time of single cycle:
approx. 20 minutes

Courtesy of the artist and Sean Kelly
Gallery, New York

CONTRIBUTORS

George Baker is an assistant professor of art history at the University of California, Los Angeles (UCLA), and an editor of *October*. He is at work on a book on dada in Paris titled *The Artwork Caught by the Tail* and has recently edited a book of essays on the work of James Coleman (Cambridge: MIT Press, 2003) and published a catalogue on his work in film (Hannover: Sprengel Museum, 2002).

Gregg Bordowitz is a writer, video/film maker, and teacher. He is currently an associate professor at the School of the Art Institute of Chicago and a member of the faculty at the Whitney Museum Independent Study Program. His video/films include *Fast Trip Long Drop* (1993) and *Habit* (2001). A collection of his essays will be published by MIT Press in 2004.

Aruna D'Souza is an assistant professor of art history at Binghamton University, State University of New York. She is author of the forthcoming book *Cézanne's Bathers, Biography, and the Erotics of Paint* (University Park: Penn State University Press, 2004) and is currently working on a collection of essays on the issues of gender and public space in the work of a number of contemporary artists.

Bill Horrigan has been curator of media arts at the Wexner Center since 1989, where he has developed projects with such artists as Johan van der Keuken, Chris Marker, Paper Tiger Television, Julia Scher, Mark Dion, John Waters, and Shirin Neshat, among others

Bruce Jenkins is the Stanley Cavell Curator of the Harvard Film Archive and a senior lecturer in visual and environmental studies at Harvard University. He is a coauthor of *Hollis Frampton: Recollections/Recreations* (Cambridge: MIT Press, 1984) and *2000 BC: The Bruce Conner Story, Part II* (Minneapolis: Walker Art Center, 1999).

Helen Molesworth is the chief curator of exhibitions at the Wexner Center. From 2000 to 2003 she was the curator of contemporary art at The Baltimore Museum of Art, where she organized exhibitions including *Work Ethic* and *BodySpace.* Her writing has appeared in publications such as *Art Journal, Documents,* and *October.*

Hamza Walker is director of education at The Renaissance Society at The University of Chicago.

ACKNOWLEDGMENTS

It is easy to thank the eight artists in *Image Stream*—Kutlug Ataman, Matthew Barney, Tacita Dean, Andrea Fraser, Pierre Huyghe, Neil Jordan, Donald Moffett, and Lorna Simpson—for making such bold and innovative works in the ever changing medium of gallery-based projected works. And although they share all of the restraints and peculiarities of time-based art, their oeuvres couldn't be more different from one another. This heterogeneity is in and of itself a testament to the plasticity of the medium and the creative suppleness of the artists who deploy it. The diversity of the art is matched by the numerous methodologies brought to bear in the catalogue essays. George Baker, Gregg Bordowitz, Aruna D'Souza, Bill Horrigan, Bruce Jenkins, and Hamza Walker each help to unravel the intricacies of individual works in the exhibition, adding to the steady stream of interpretation that these works will engender.

Staff members at the artists' galleries and at the lending institutions have been unfailingly helpful and cooperative. I join the Wexner Center's exhibitions team in thanking all these colleagues, among them Catherine Marshall and Marguerite O'Molloy of the Irish Museum of Modern Art, Jude Palmese of the Museum of Contemporary Art, Chicago, Jay Sanders of Marianne Boesky Gallery, Carter Mull and Kelly Kyst of Barbara Gladstone Gallery, Elaine Budin and Catherine Belloy of Marian Goodman Gallery, Amy Gotzler of Sean Kelly Gallery, Juliet Gray of Lehmann Maupin Gallery, and Maureen Sarro of the Friedrich Petzel Gallery.

Image Stream was the first exhibition I organized at the Wexner Center. It has been a pleasure to work with all of the staff who helped to bring this exhibition to fruition in under a year's time. I extend my heartfelt thanks to the entire staff for all their work large and small, seen and unseen. Special thanks

are due to Curatorial Assistants Steve Hunt and Joby Pottmeyer who handled all the details and kept the big picture in view; more often than not they had taken care of things before I had even thought to ask them to do so. The catalogue has been handsomely designed by Jeff Packard and skillfully edited by Ann Bremner. Exhibition Designer Benjamin Knepper, Registrar Joan Hendricks, and the whole installation team, aided by the steady hand of Stephen Jones of Technical Services, managed to transform the raw gallery space of The Belmont Building into a haven for moving images. Exhibitions Manager Jill Davis kept everyone marching along, if not in song at least in good humor. Associate Curator of Media Arts Dave Filipi and Media Arts Curatorial Assistant Chris Stults generously arranged film screenings by Kutlug Ataman and Matthew Barney in their regular film programming. Director of Education Patricia Trumps organized what promises to be a very interesting day-long symposium and other programs in conjunction with the exhibition. The Art & Technology team—Jennifer Lange, Paul Hill, and Mike Olenick—worked with Communications Manager Karen Simonian to craft a trailer for the exhibition designed to be screened in movie theaters, as well as on television. Here's to encountering contemporary art in multiplexes across the land. I am also grateful to all of the trustees and patrons of the Wexner Center, and in particular Nancy and Dave Gill.

My final thanks are reserved for Curator of Media Arts Bill Horrigan and Director Sherri Geldin. *Image Stream* emerged from numerous conversations with Bill; his suggestions for the checklist helped to fashion a smarter exhibition than I could have organized alone. Sherri's support and intelligent engagement with the material were a continual source of pleasurable intellectual provocation.

HM

**Wexner Center for the Arts
Wexner Center Foundation
Staff**

Elizabeth Tarpy Alcalde
Su Au Arnold
Scott Austin
David Bamber
William Barto
Bruce Bartoo
Claudia Bonham
Ann Bremner
Jeffrey Byars
Shelly Casto
Sarah Cathers
Cynthia Collins
Barbara Congrove
Christopher Conti
Emily Daughtridge
Jill Davis
Kristel Davis-Smith
Misty Dickerson-Ray
Christopher Dorman
David Filipi
Kristine Flaherty
Brigid Flynn
Peg Fochtman
Sherri Geldin
Kendra Girardot
Adelia Gregory
Kevin Hathaway
Pug Heller
Charles Helm
Joan Hendricks
Andrew Hensler
Cara Hering
Paul Hill
Sara Hill

Zonia Horn
Bill Horrigan
Paul Jones
Stephen Jones
Kate Joranson
Benjamin Knepper
Jennifer Lange
Darnell Lautt
Ken Luke
Jenny Macy
Ben Mamphey
Annetta Massie
Michael Metz
Gretchen Metzelaars
Mychaelyn Michalec
Helen Molesworth
Don Nelson
Mike Olenick
Nick Orosan
Ryan Osborn
Tracy Owens
Jeffrey M Packard
James Petsche
Jennifer Roy
Jennifer Scarbrough
James A. Scott
Laura Scudiere
Mandi Semple
Erin Senften
Ryan Shafer
Alyssa Shenk
Karen Simonian
Megan Slayter
John A. Smith

Myung Jin Song
Mark Spurgeon
Stef Stahl
Timothy Steele
Christopher Stults
Michael Sullivan
Ilana Tannenbaum
Sherri Trayser
Patricia Trumps
Alison Wales
Amy Wharton
Madeline Wimmer

Special thanks also
to all the officers and
staff of University
Security Services.

Photo credits

Page 10: Courtesy Electronic Arts Intermix (EAI), New York. Page 13 (left): Collection Wexner Center for the Arts, The Ohio State University; Purchase; © 1990 Barbara Kruger; photo: Fredrik Marsh. Page 13 (right): Courtesy of the artist and Metro Pictures Gallery. Page 16: Courtesy Sean Kelly Gallery, New York. Page 19: Courtesy of the artist and Lehmann Maupin Gallery, New York. Page 20: Courtesy of Marianne Boesky Gallery, New York. Pages 25–28: Courtesy of the artist and Lehmann Maupin Gallery, New York. Page 32: Courtesy Barbara Gladstone. Page 35: Courtesy Barbara Gladstone, © 1993 Matthew Barney, Videography: Peter Strietmann. Page 41: © 2003 The Andy Warhol Museum, Pittsburgh, PA, a museum of Carnegie Institute. Page 43: Courtesy of the artist and Marian Goodman Gallery, New York. Page 50: Courtesy of the artist and Friedrich Petzel Gallery, New York. Page 51: Courtesy Friedrich Petzel Gallery, New York. Pages 52–53: Courtesy of the artist and Friedrich Petzel Gallery, New York. Pages 62–63: Courtesy of the artist and Marian Goodman Gallery, New York. Page 71: Collection Irish Museum of Modern Art, donated by the artist, 2000, © Neil Jordan. Pages 79–82: Courtesy of Marianne Boesky Gallery, New York. Pages 87–88: Courtesy of Sean Kelly Gallery, New York. Page 90: Courtesy New Yorker Films.